# ASSASSIN'S
# CREED®

## THE OFFICIAL COLORING BOOK

INSIGHT EDITIONS

*San Rafael, California*

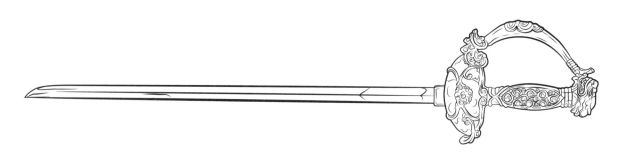

The story of the eternal struggle of Assassin versus Templar, Assassin's Creed spans from the Crusades and the American Revolution to the Golden Age of Piracy, Victorian London, and beyond. From the deep blues and greens of the Caribbean Ocean to the vibrant reds and oranges of India, these pages offer centuries of history to fill with color. So equip your hidden blade, grab your colored pencils, and start your journey through the world of Assassin's Creed.

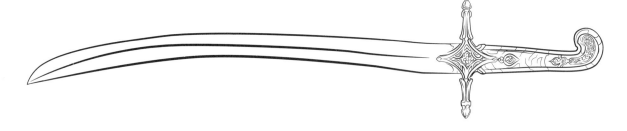

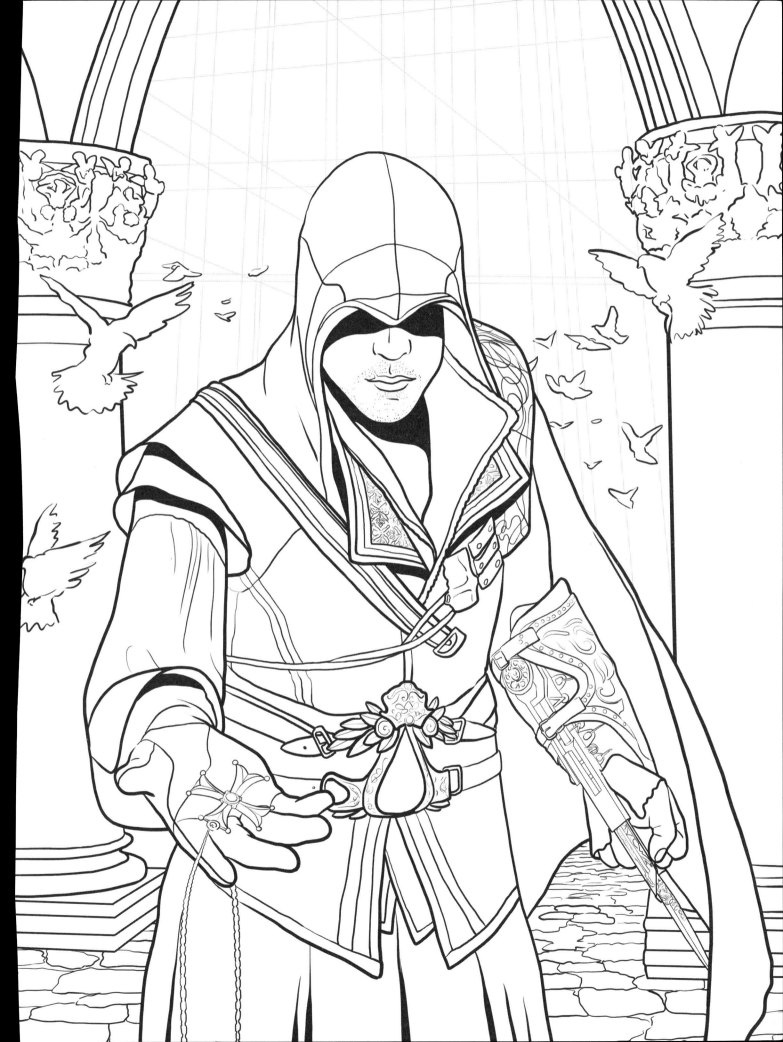

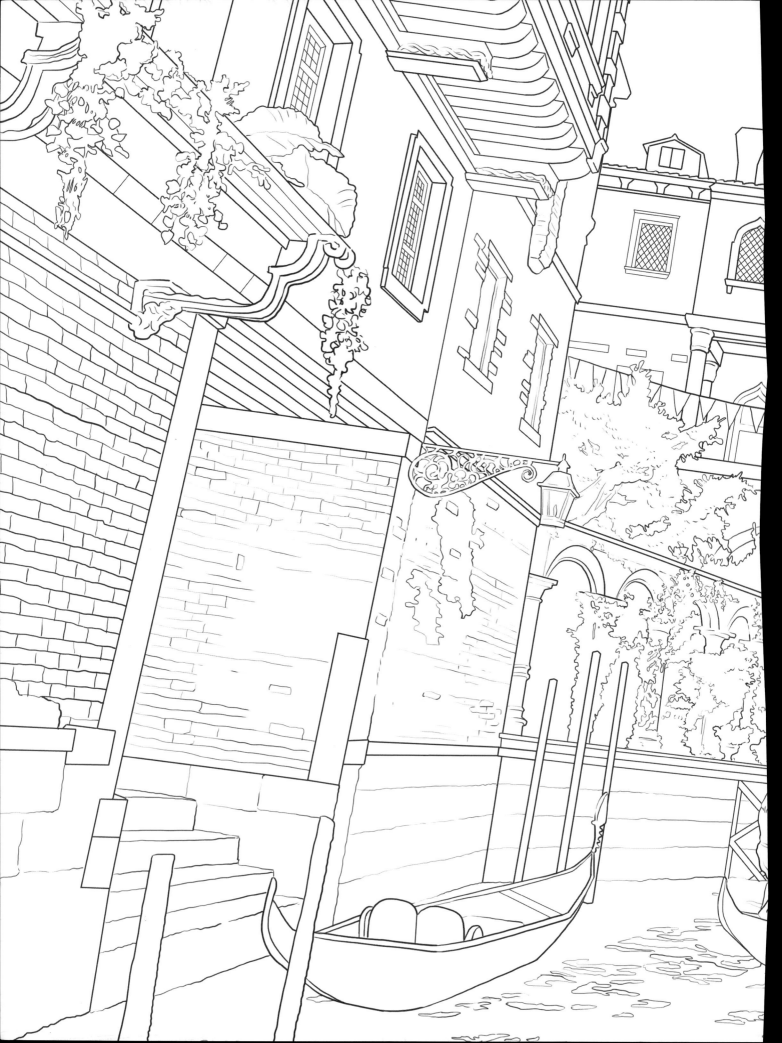

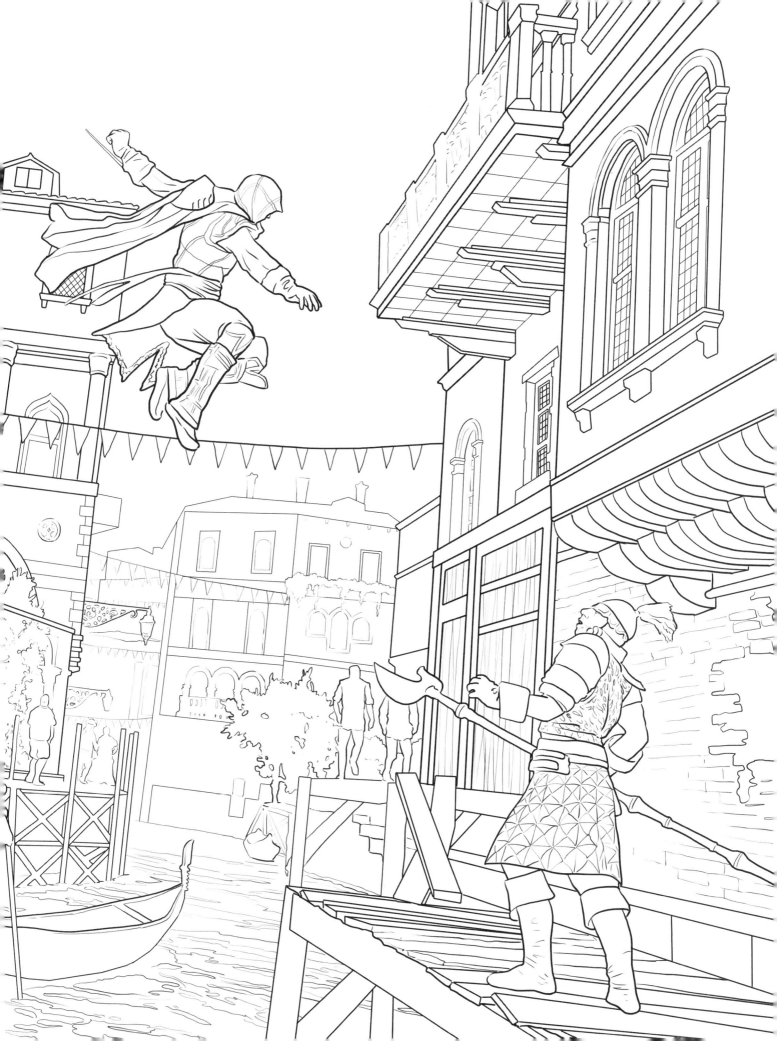

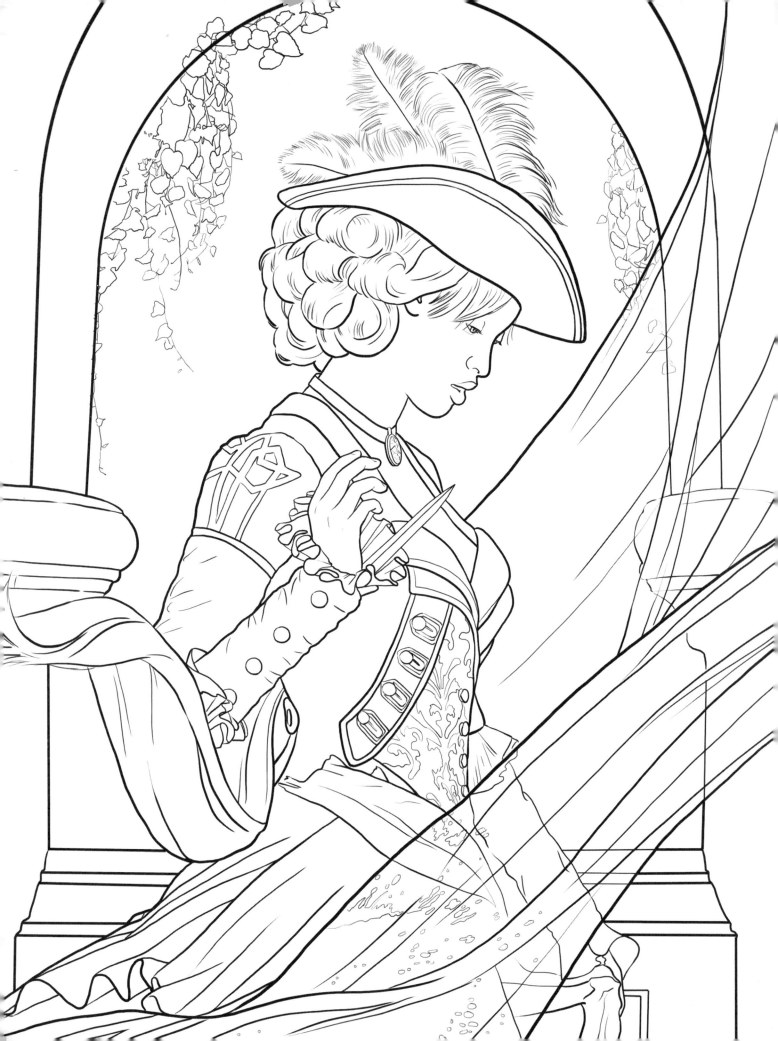

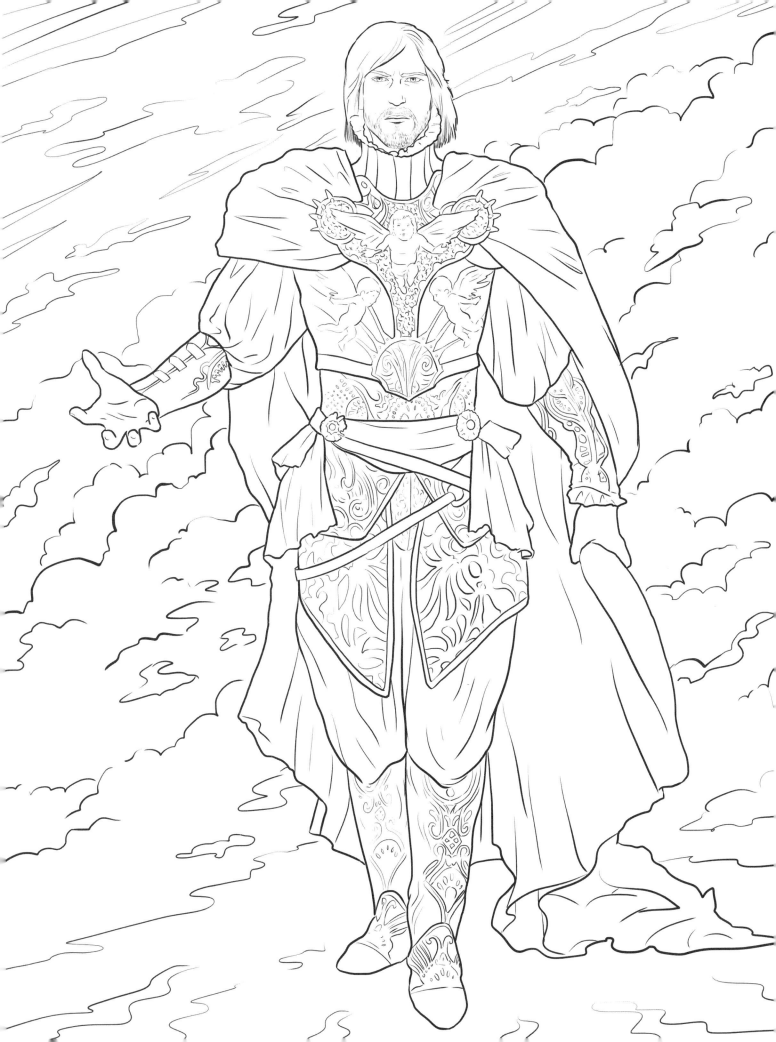

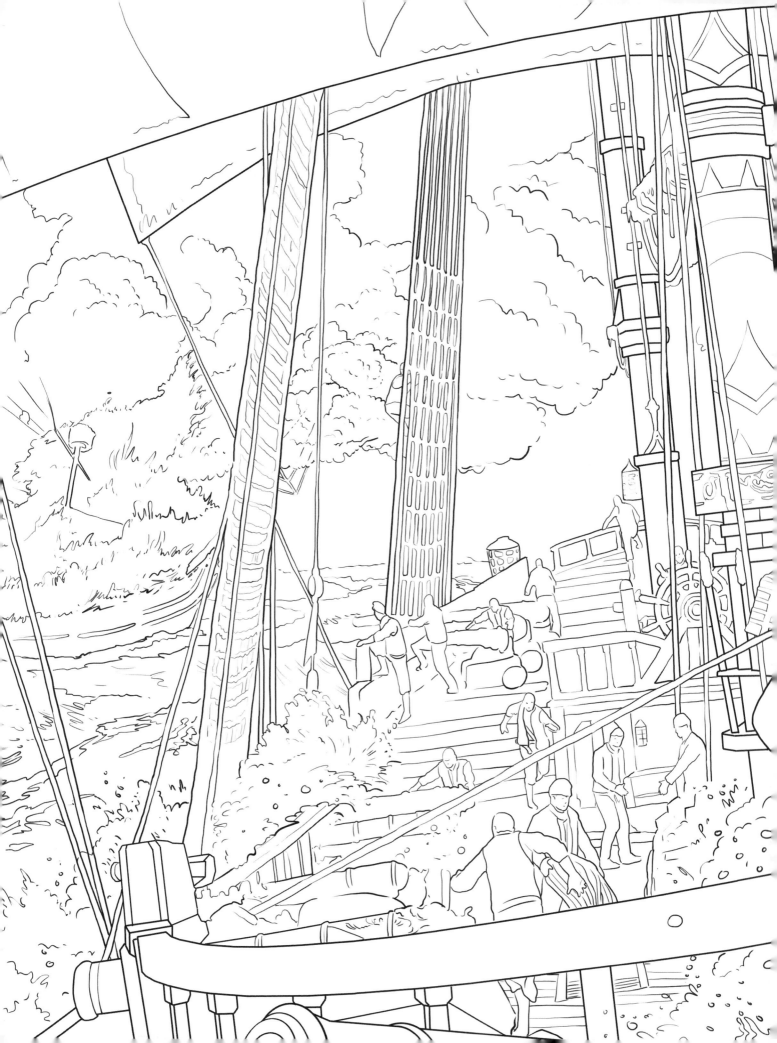

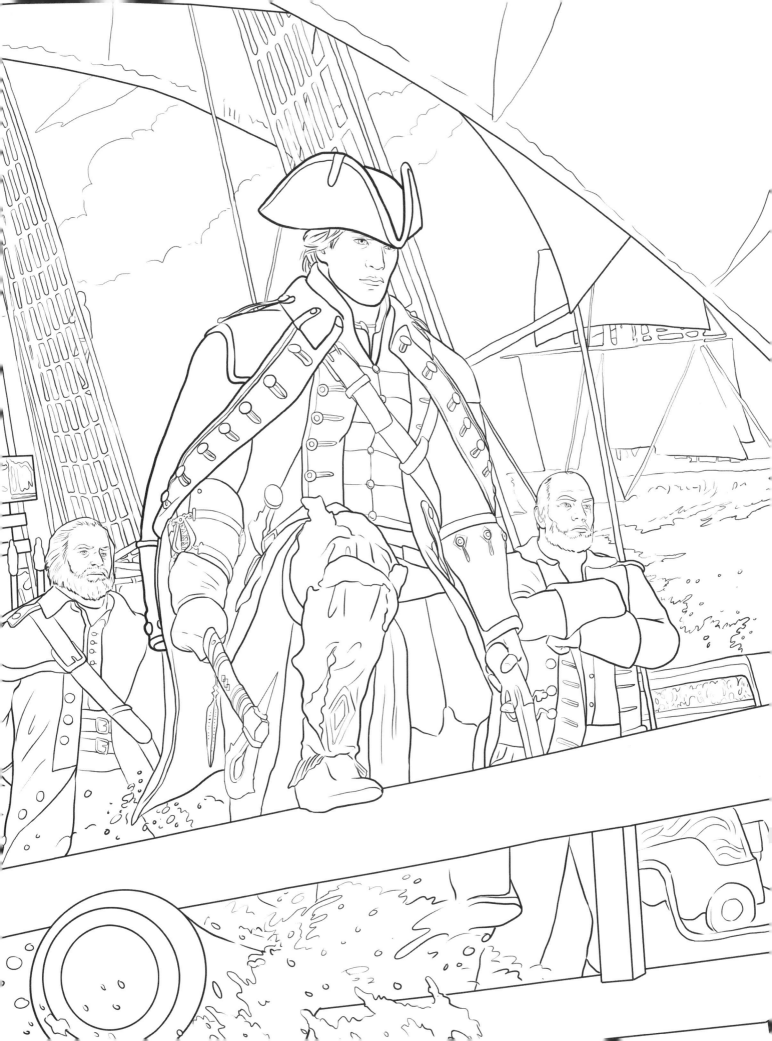

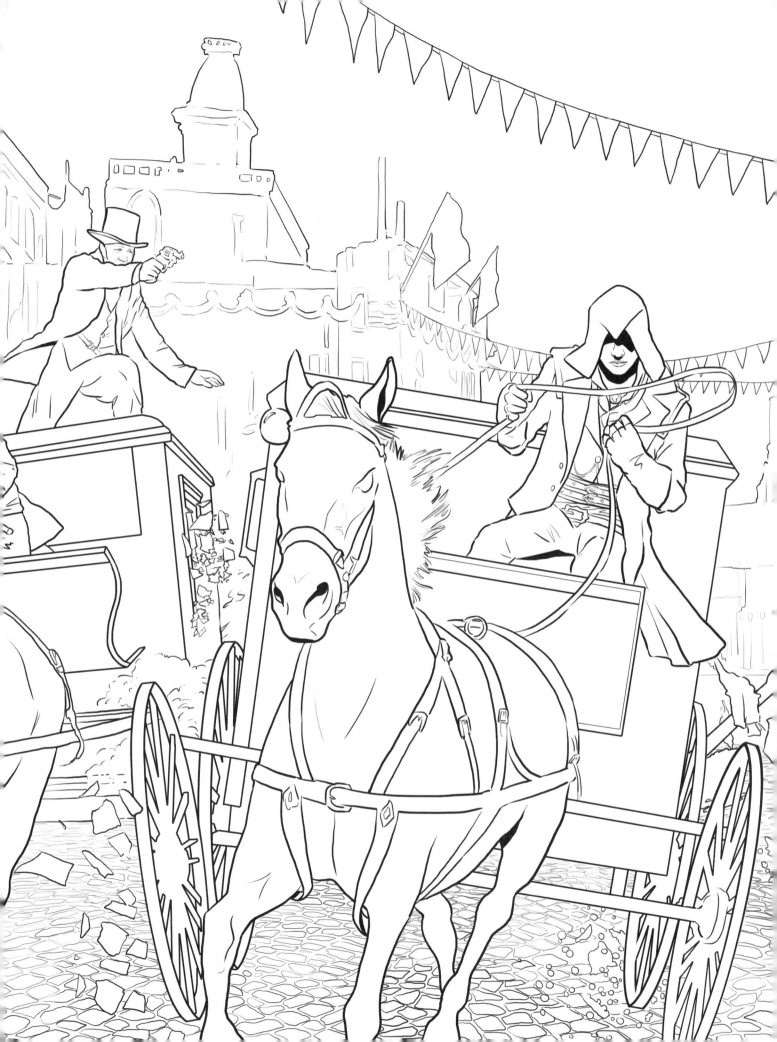

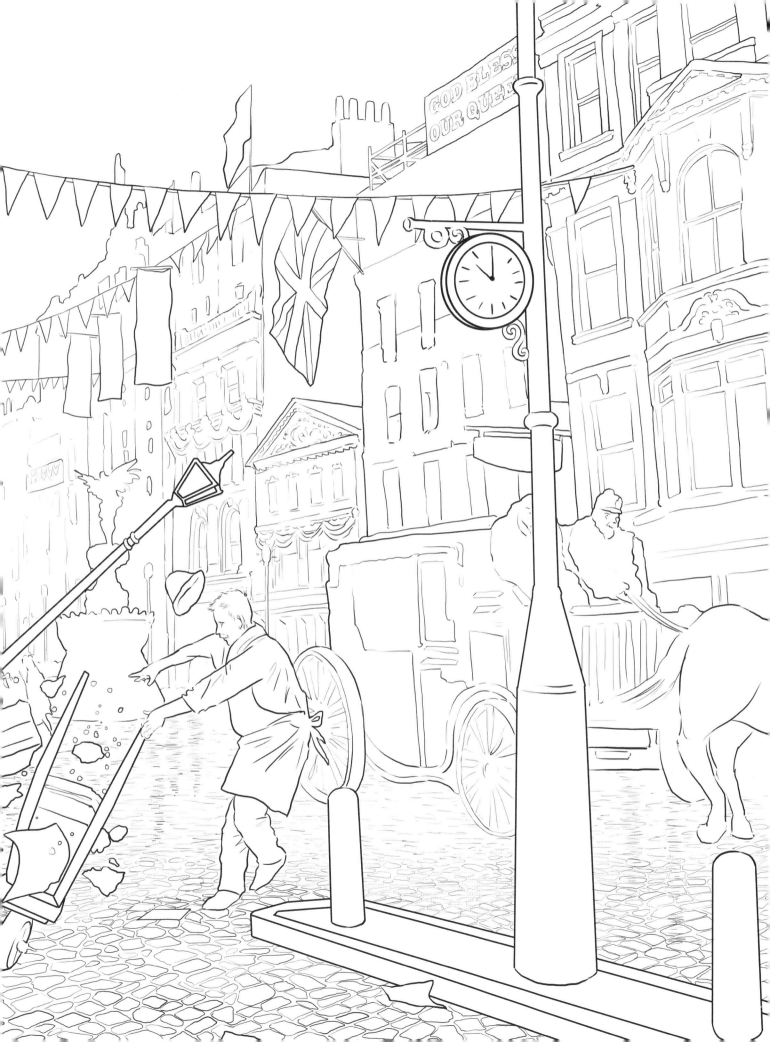

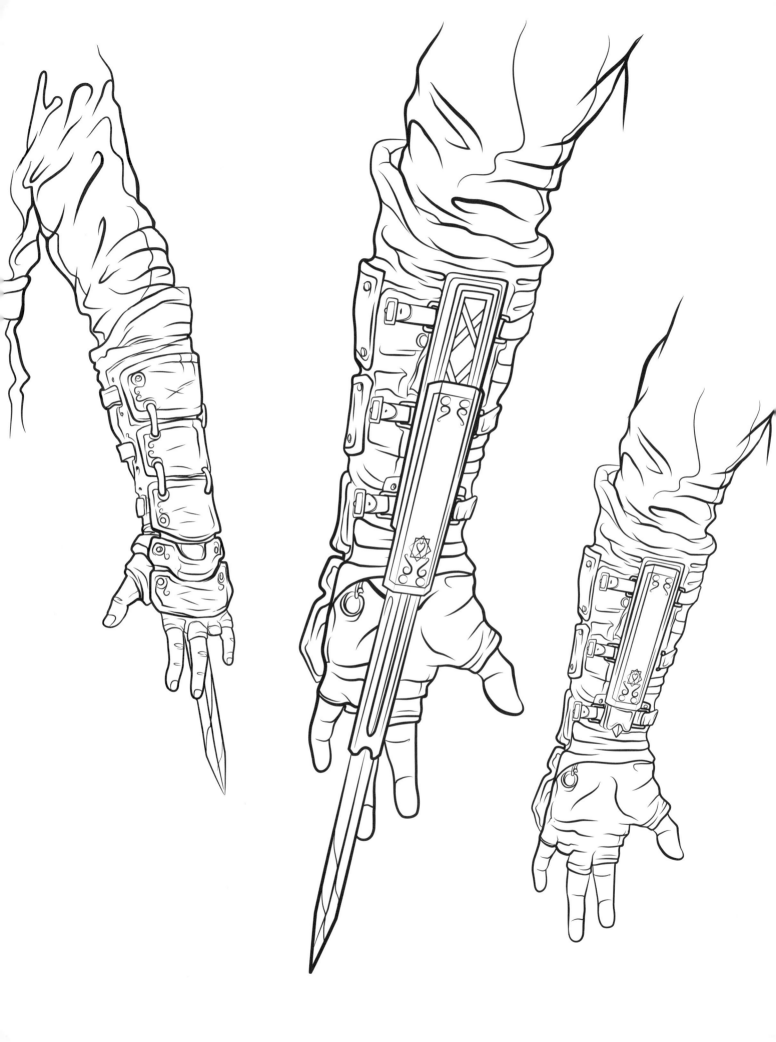

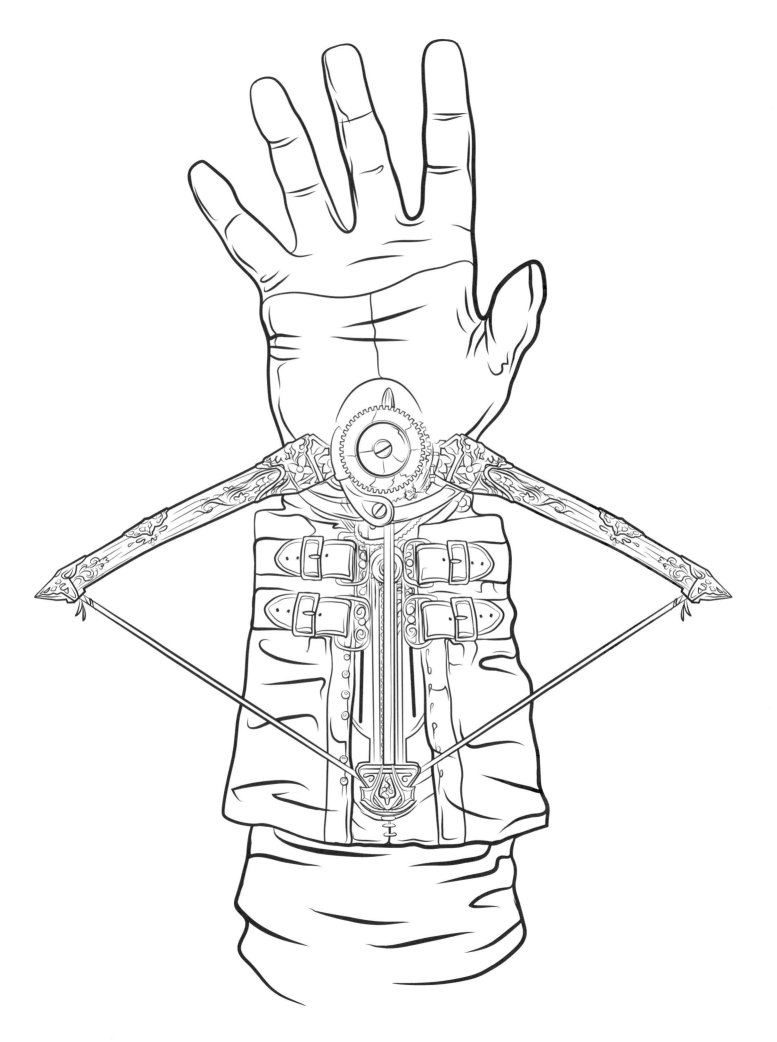

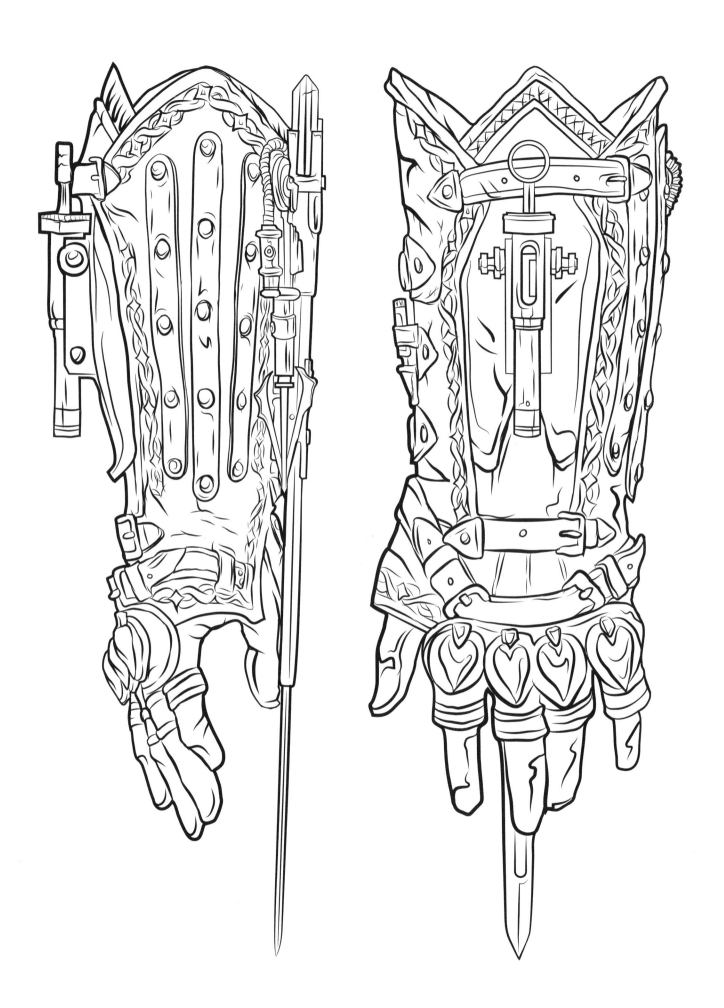

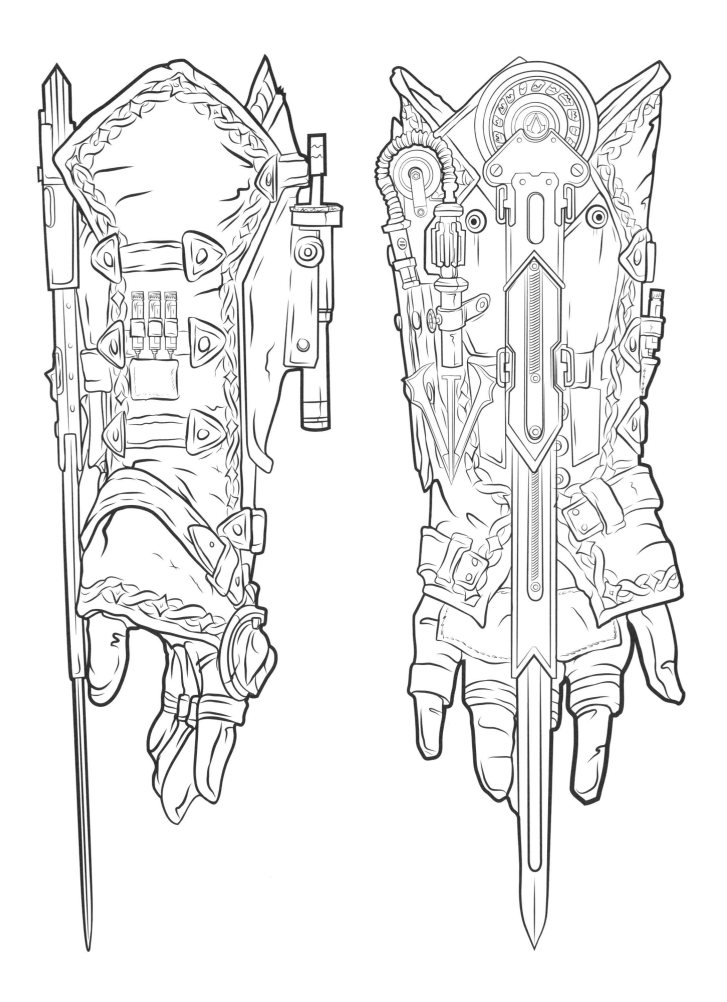

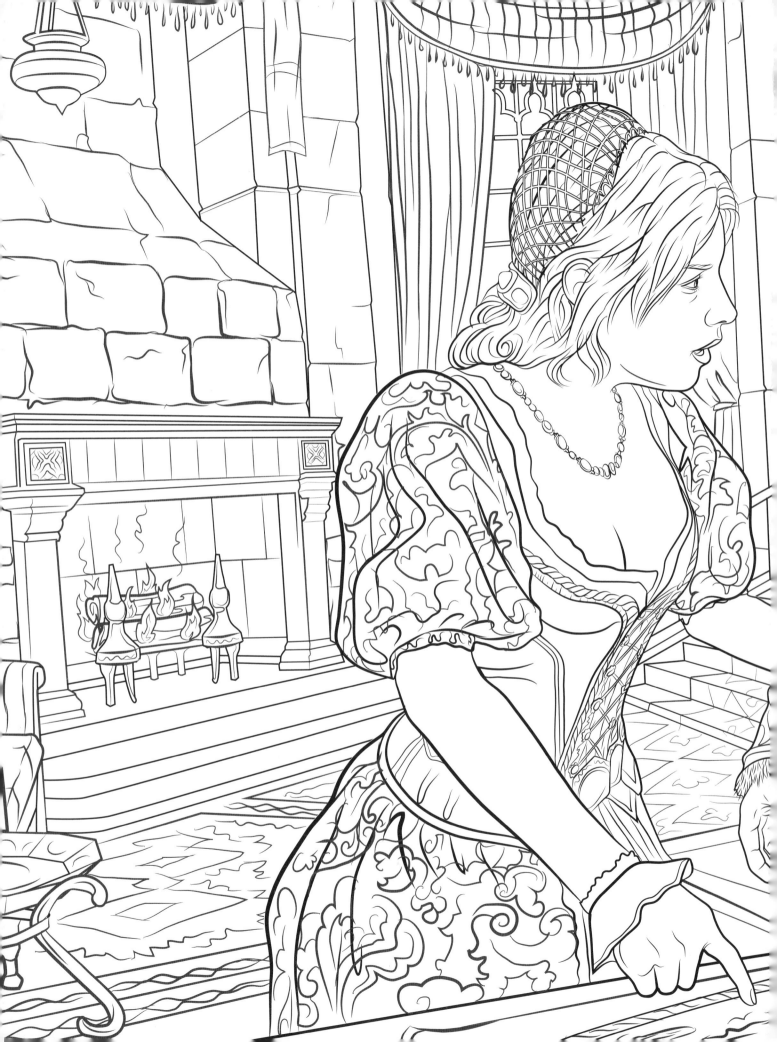

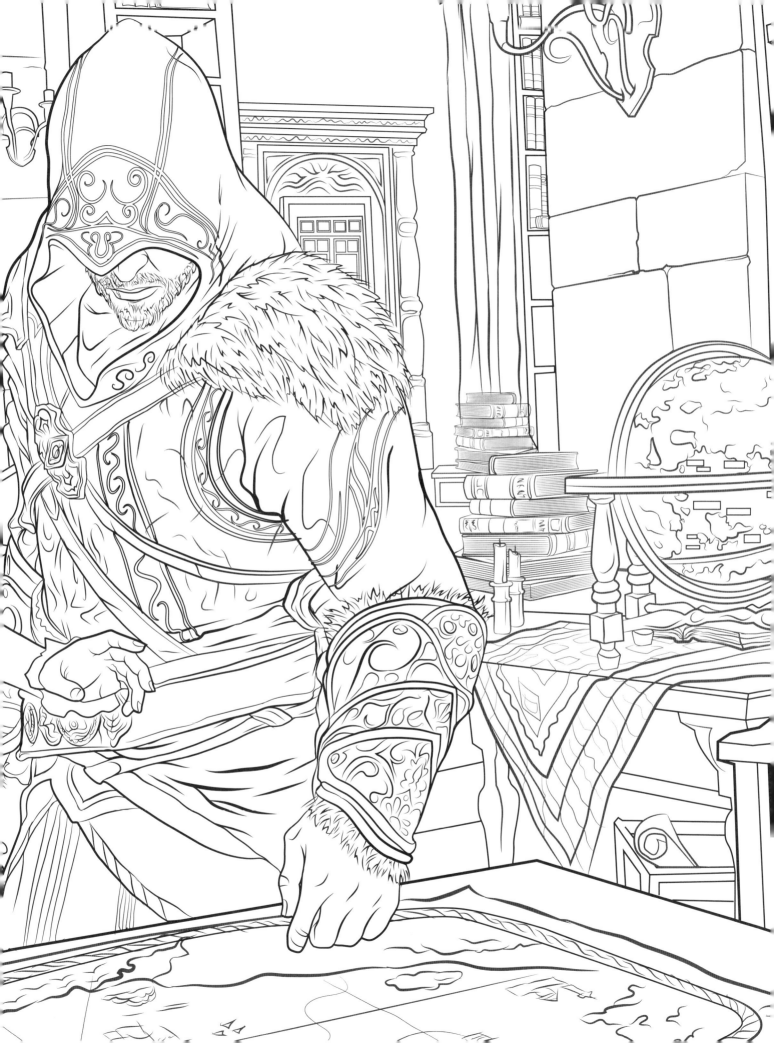

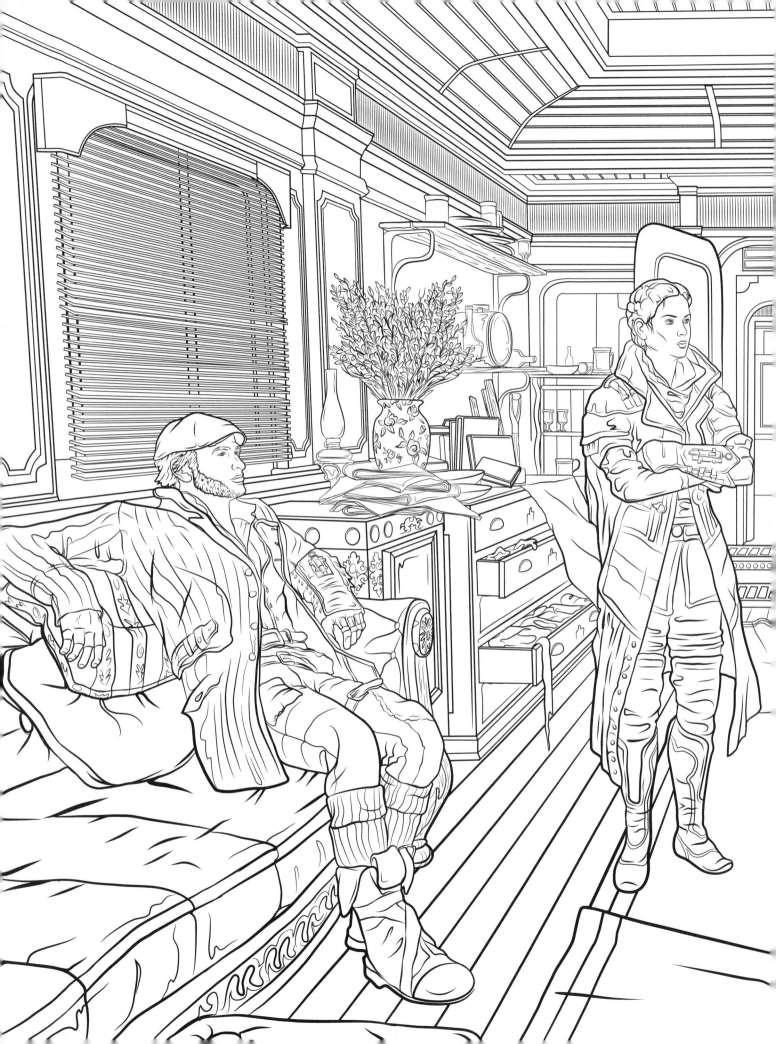

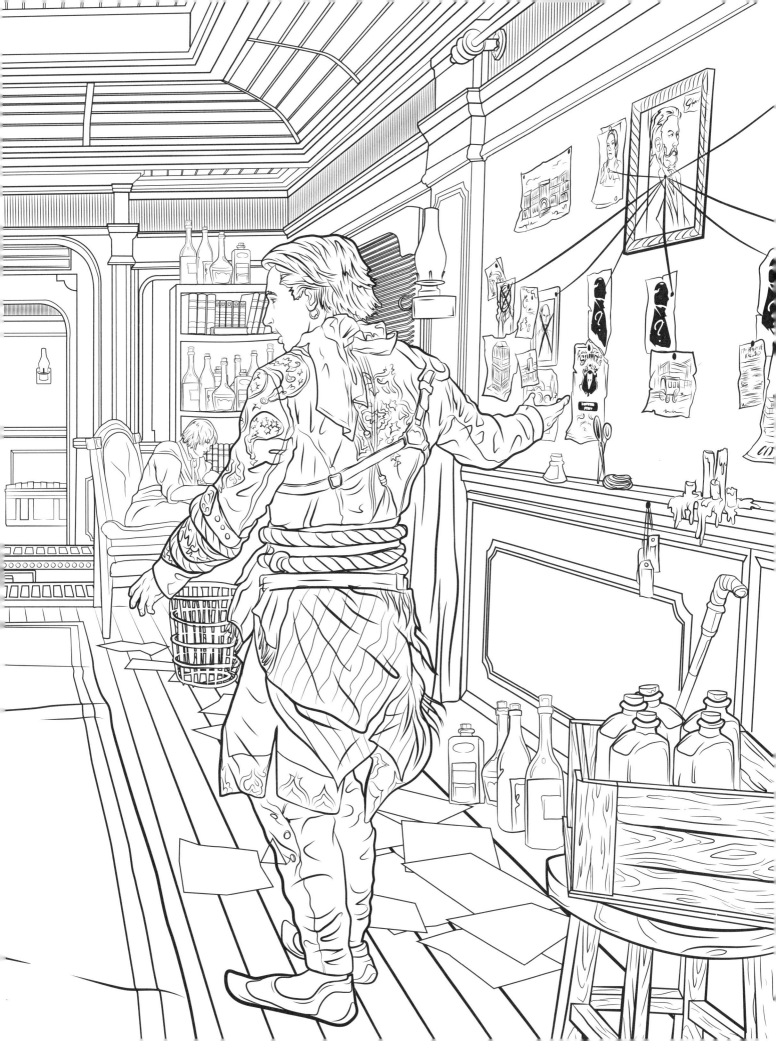

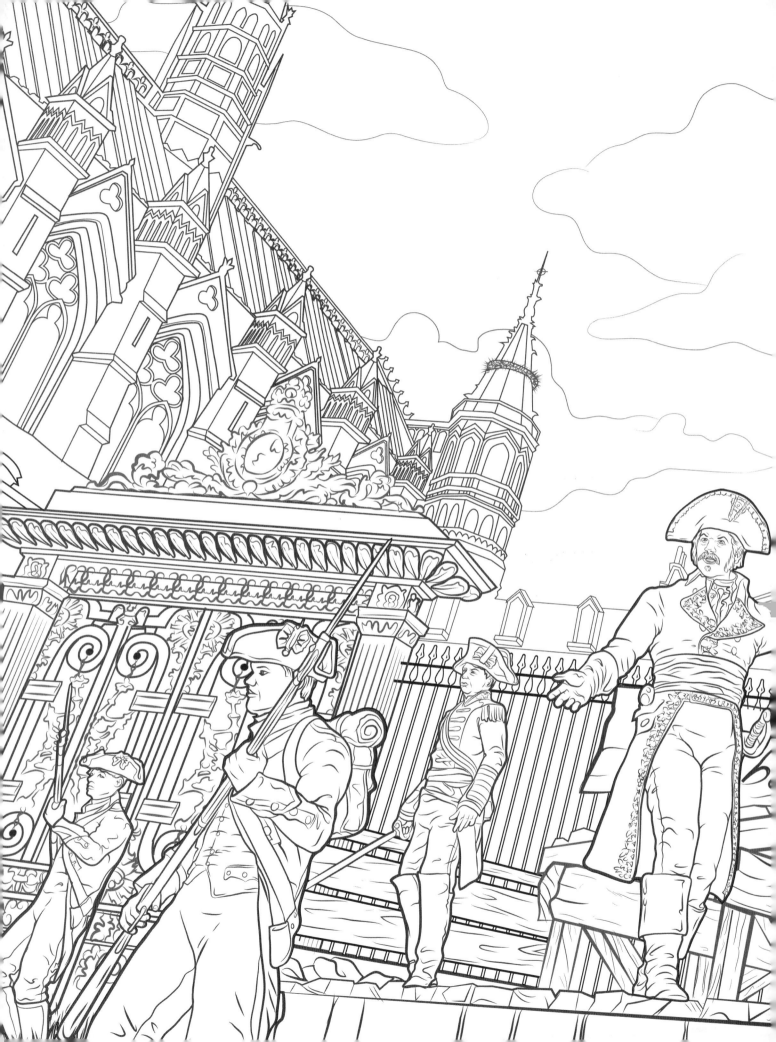

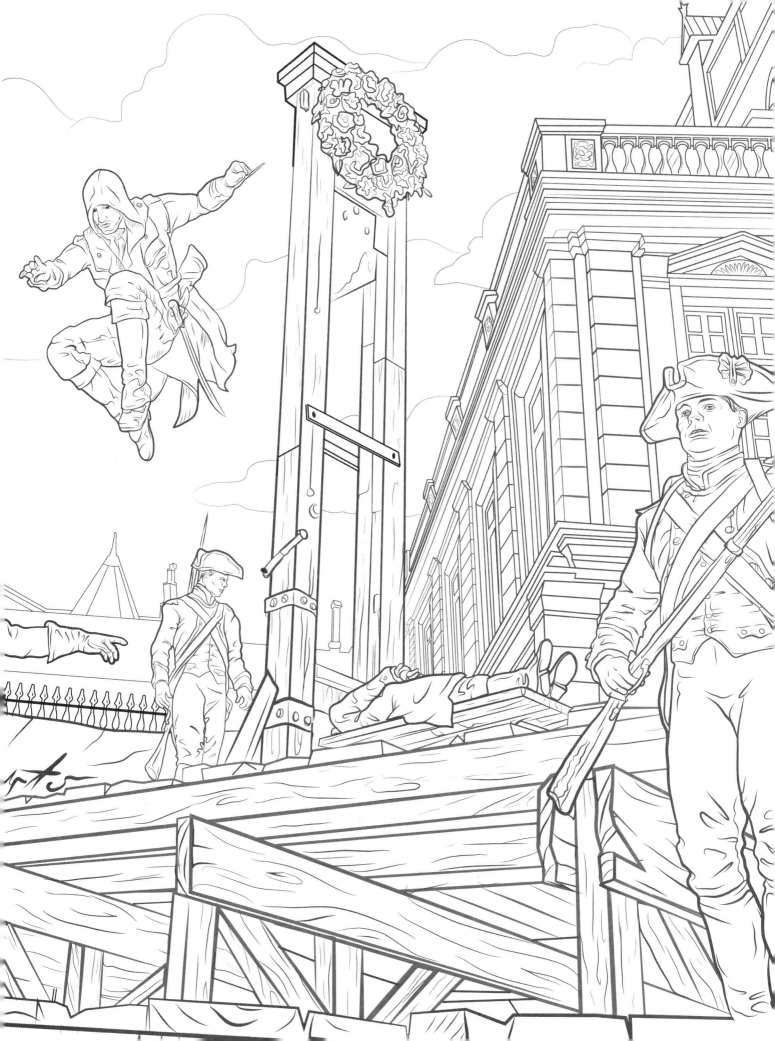

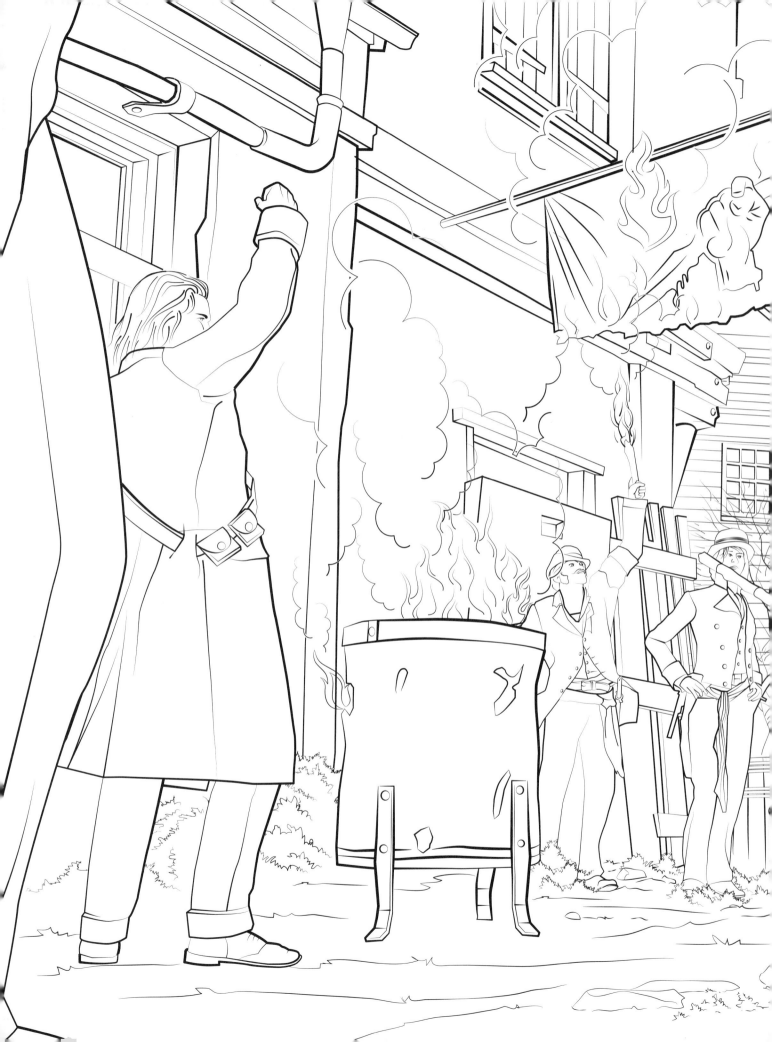

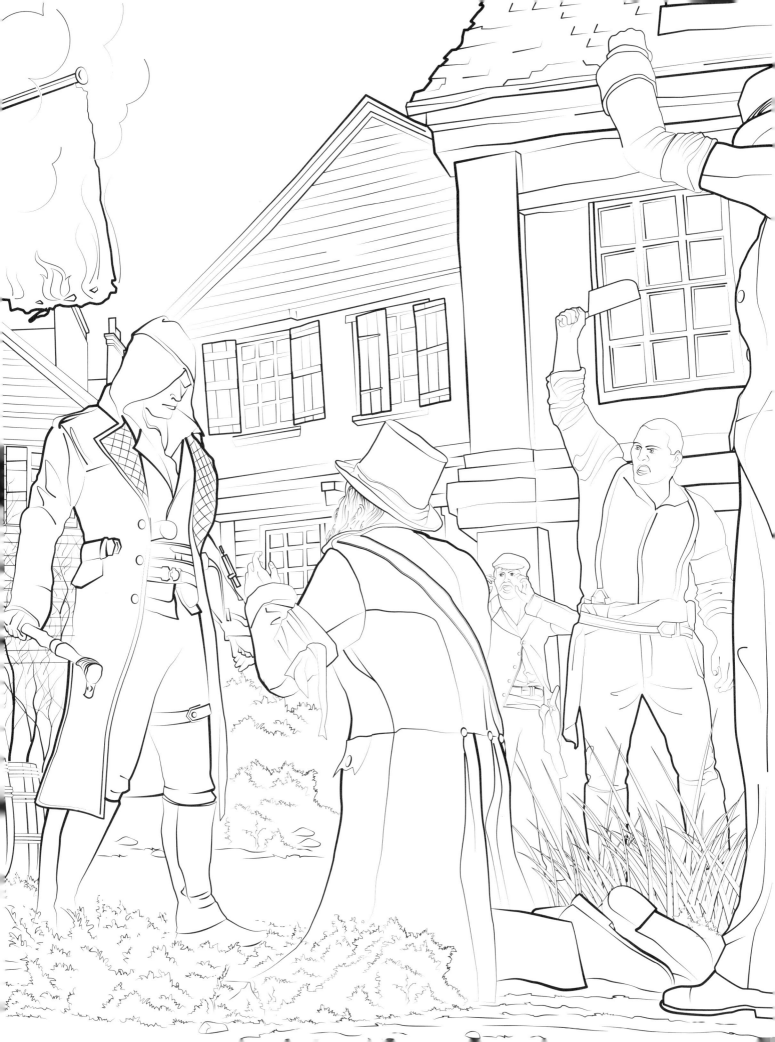

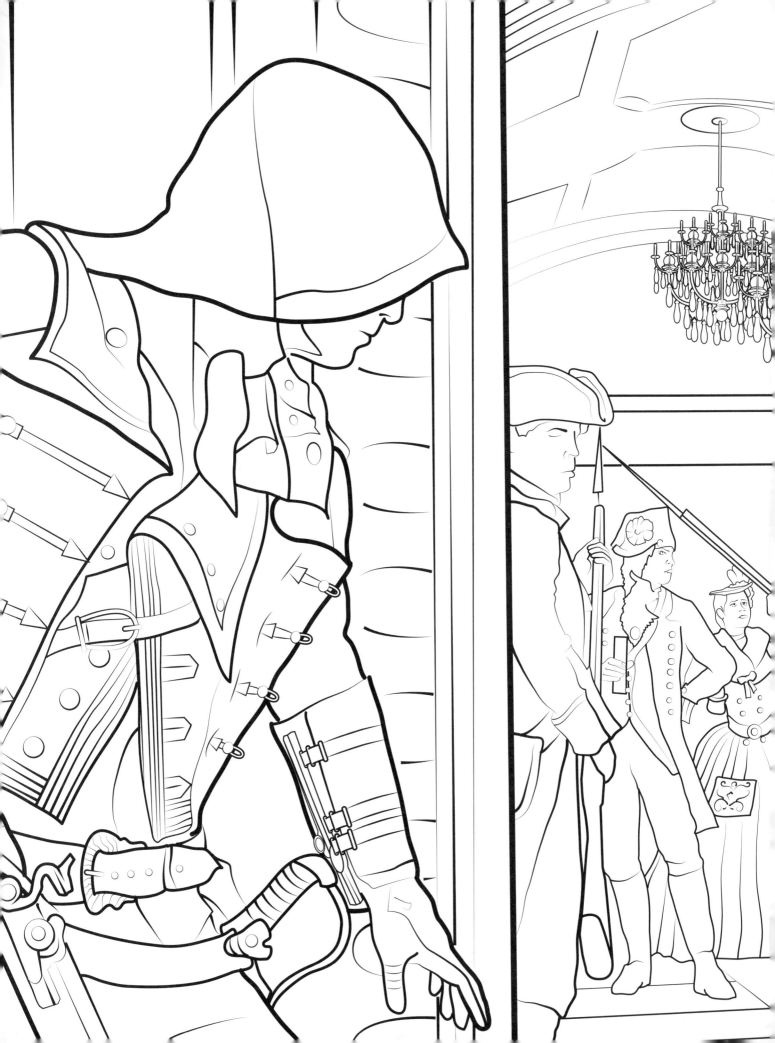

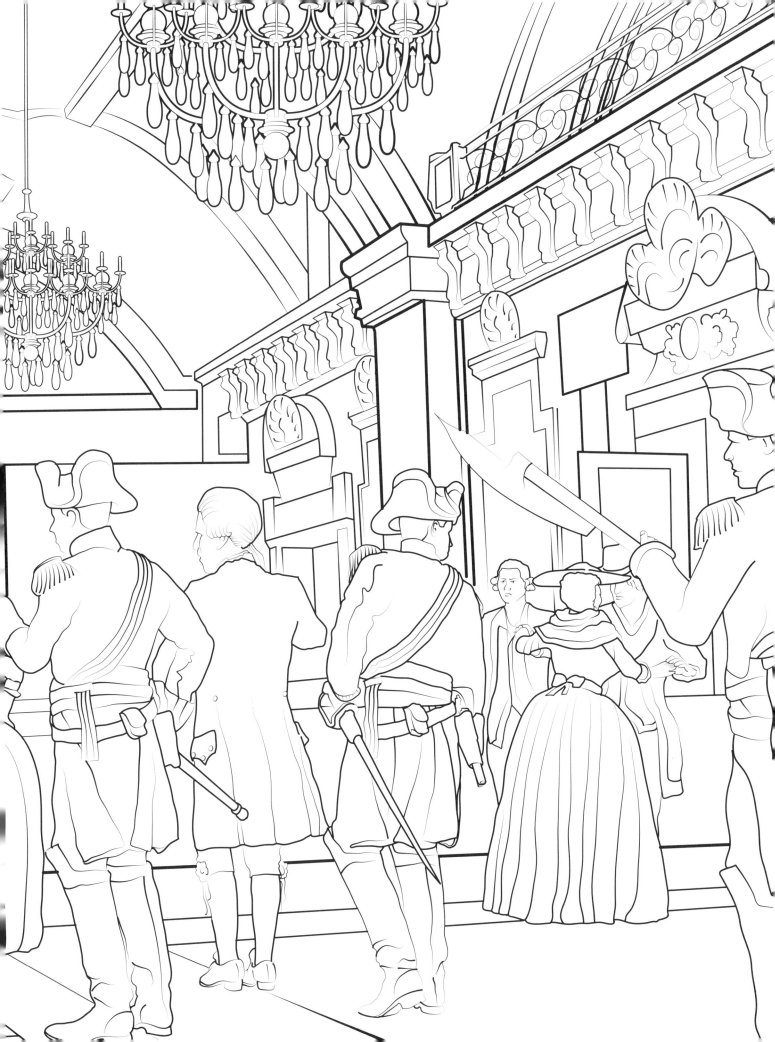

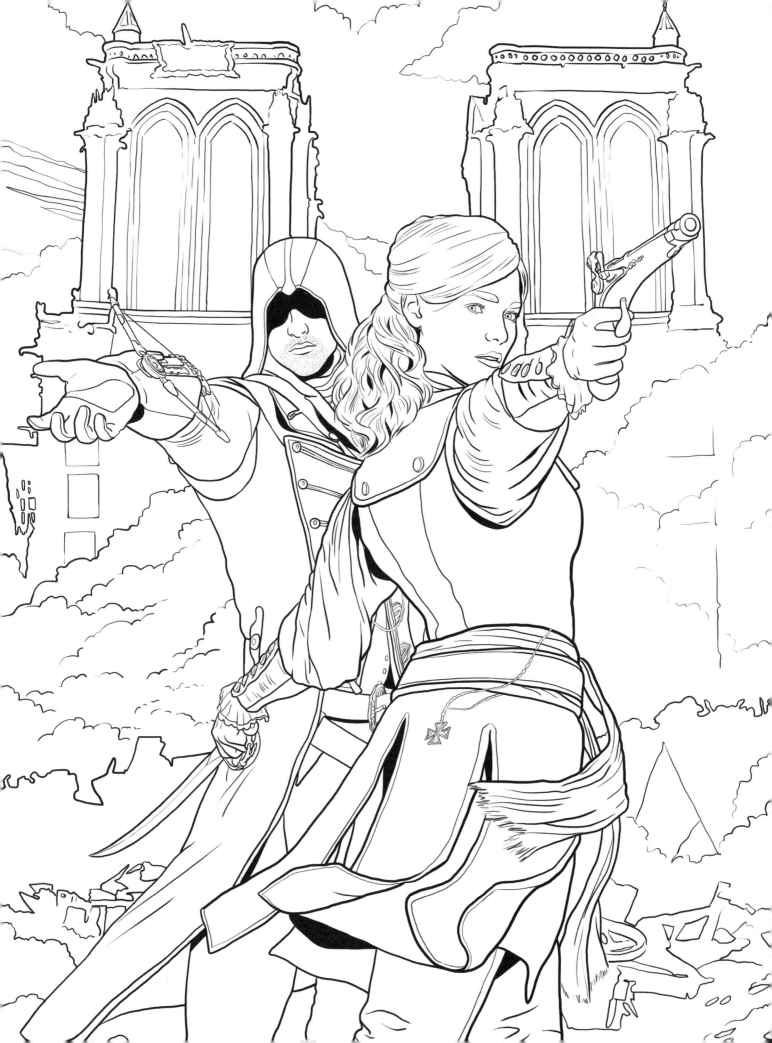

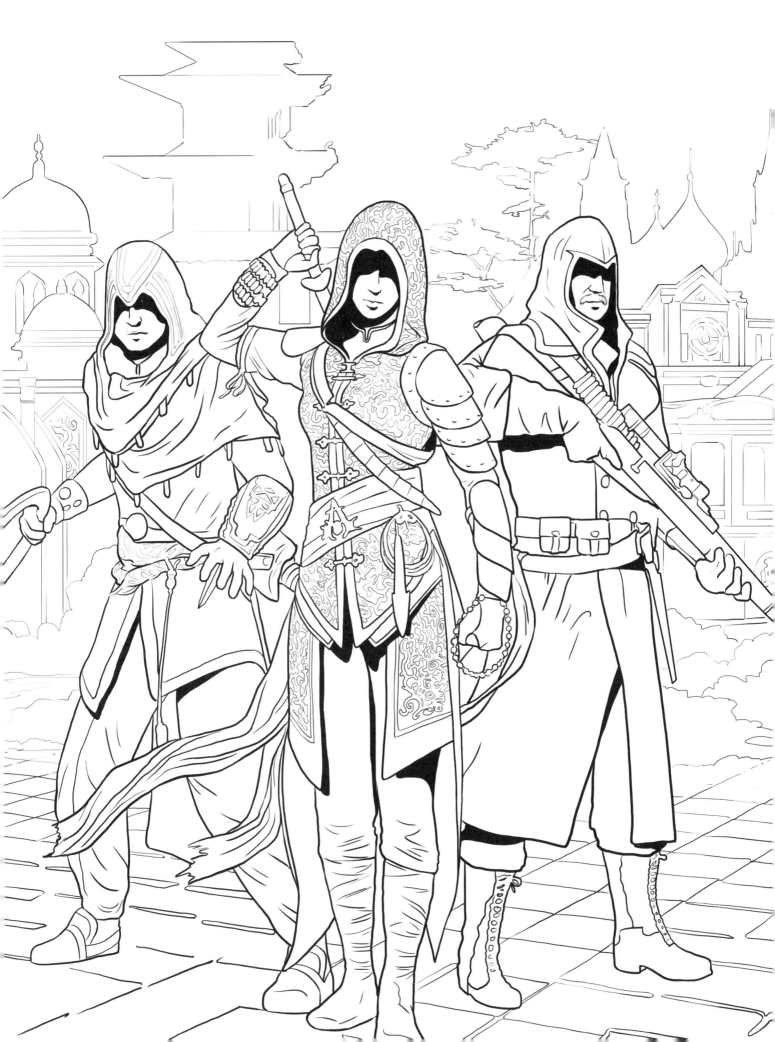

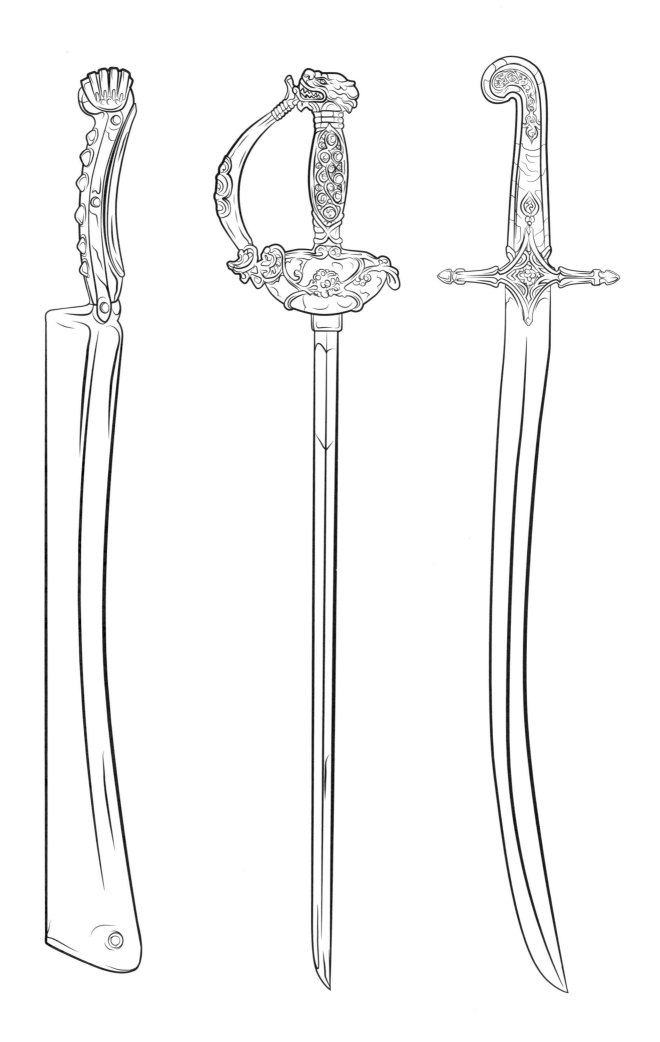

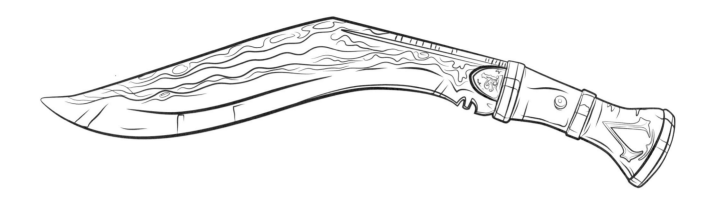
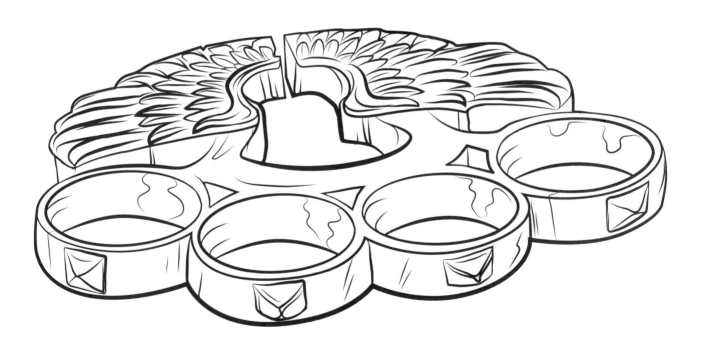

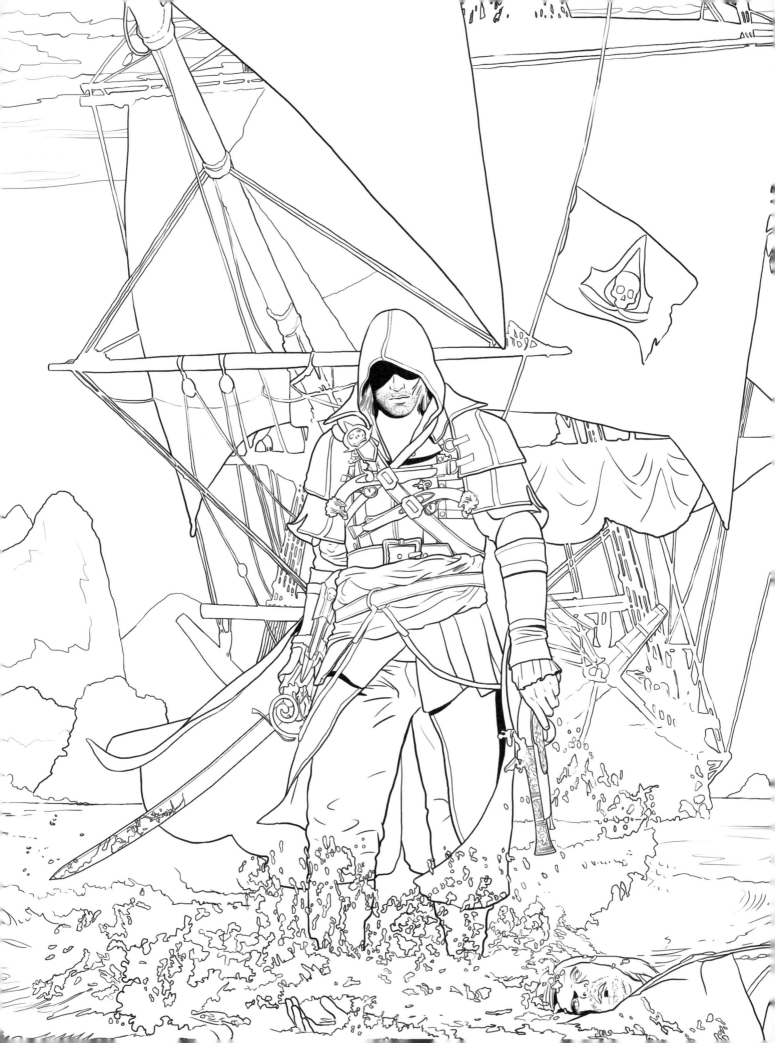

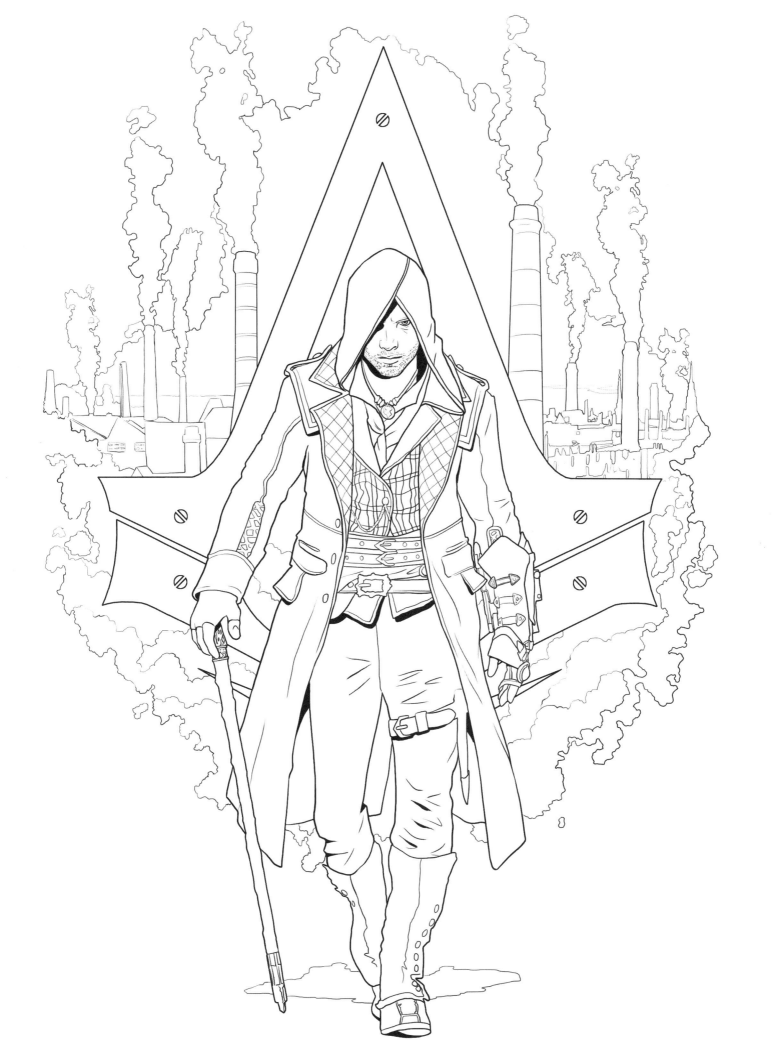

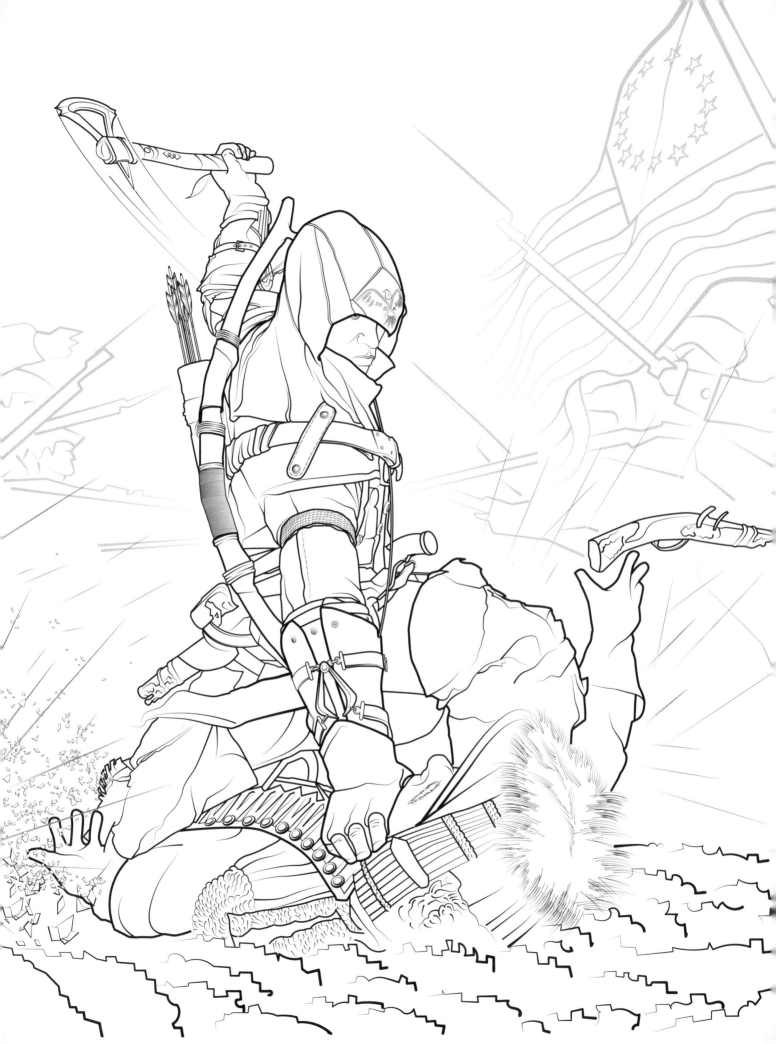

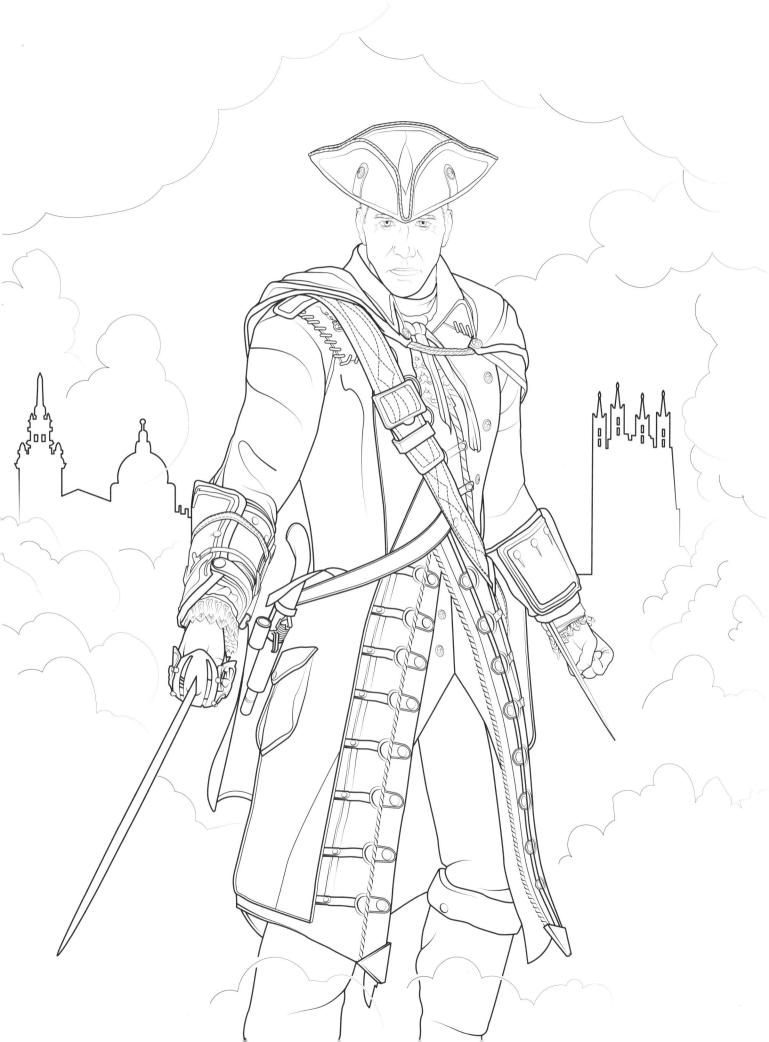

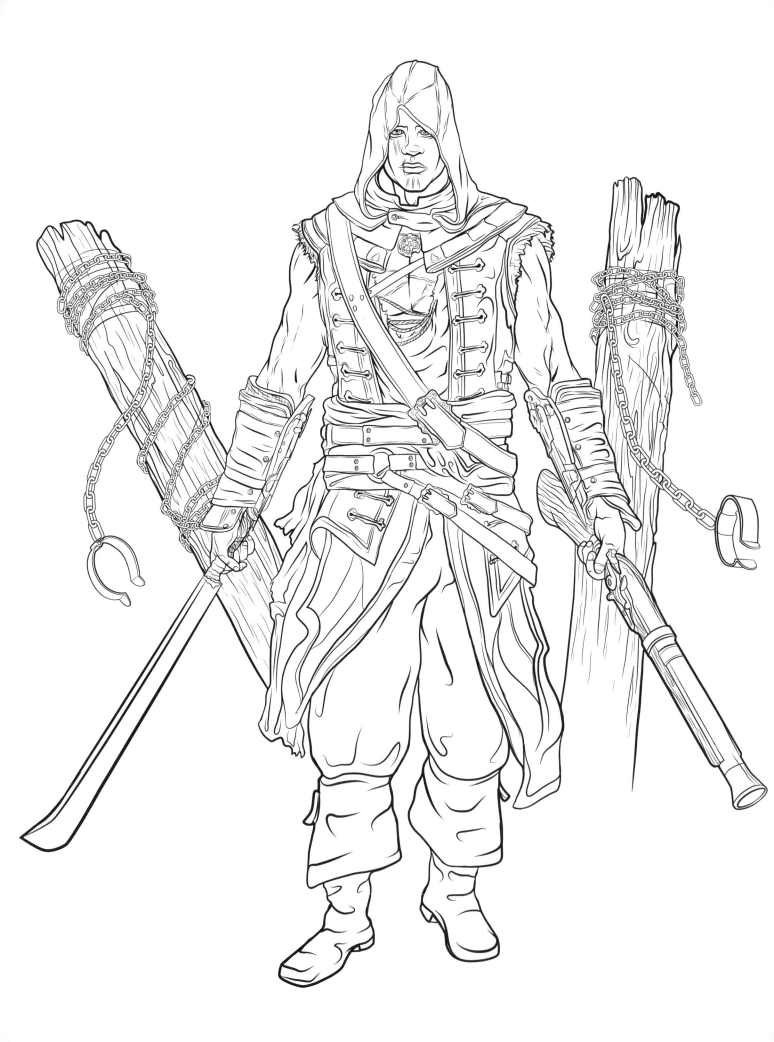

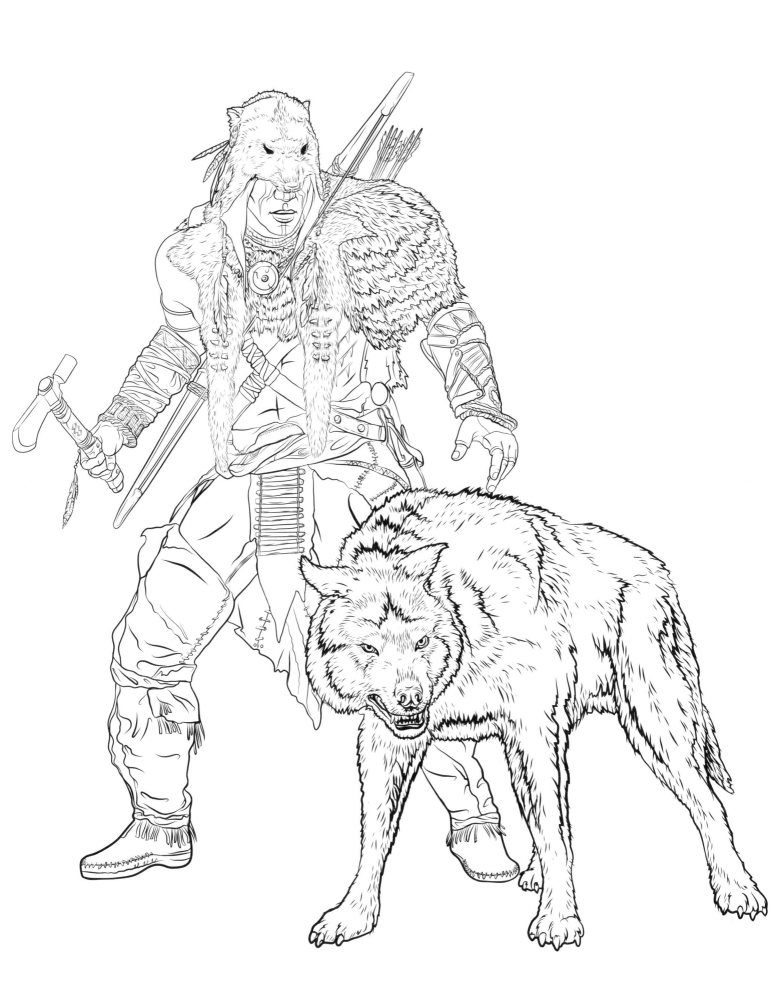

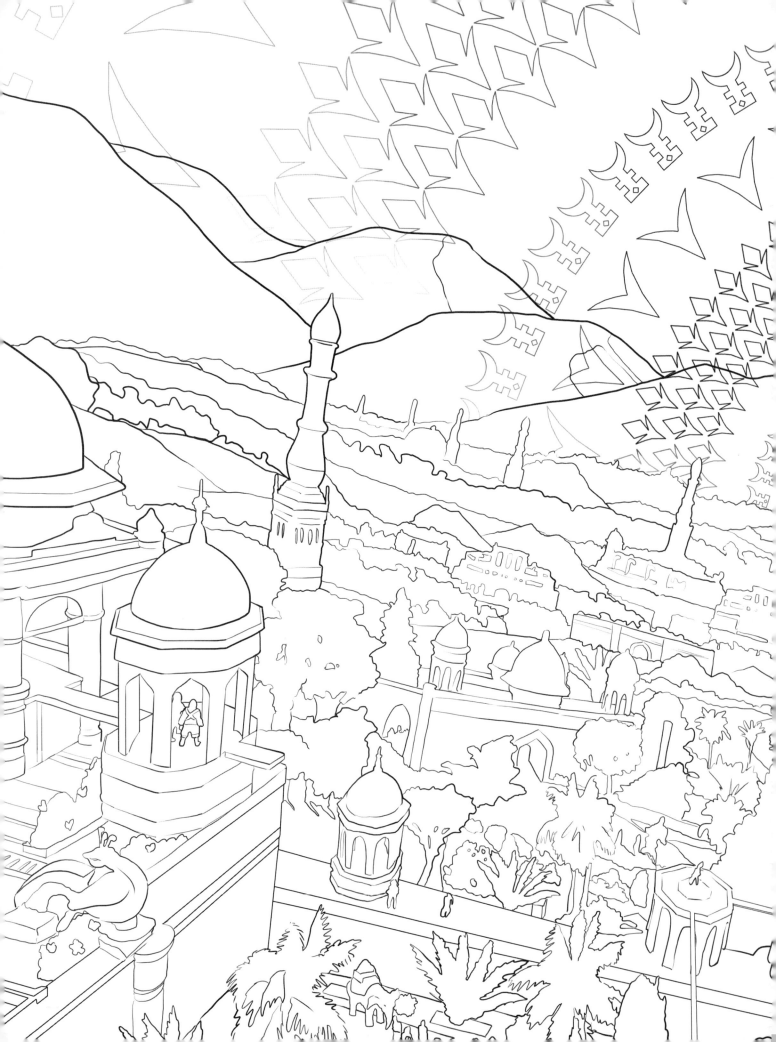

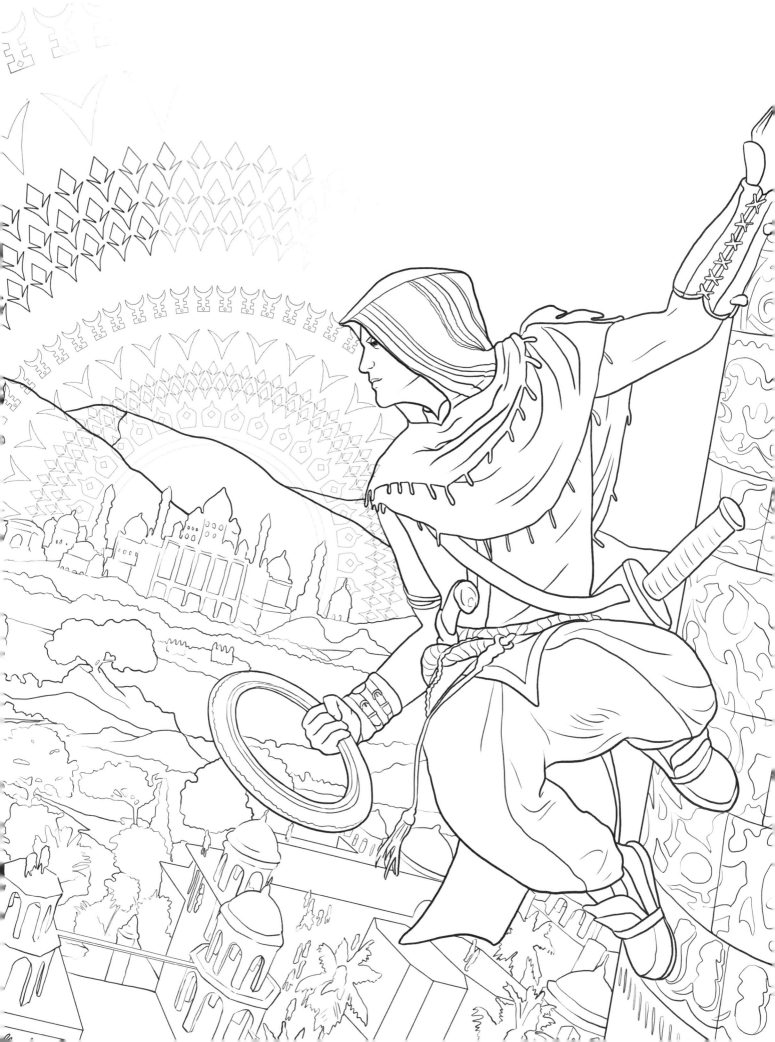

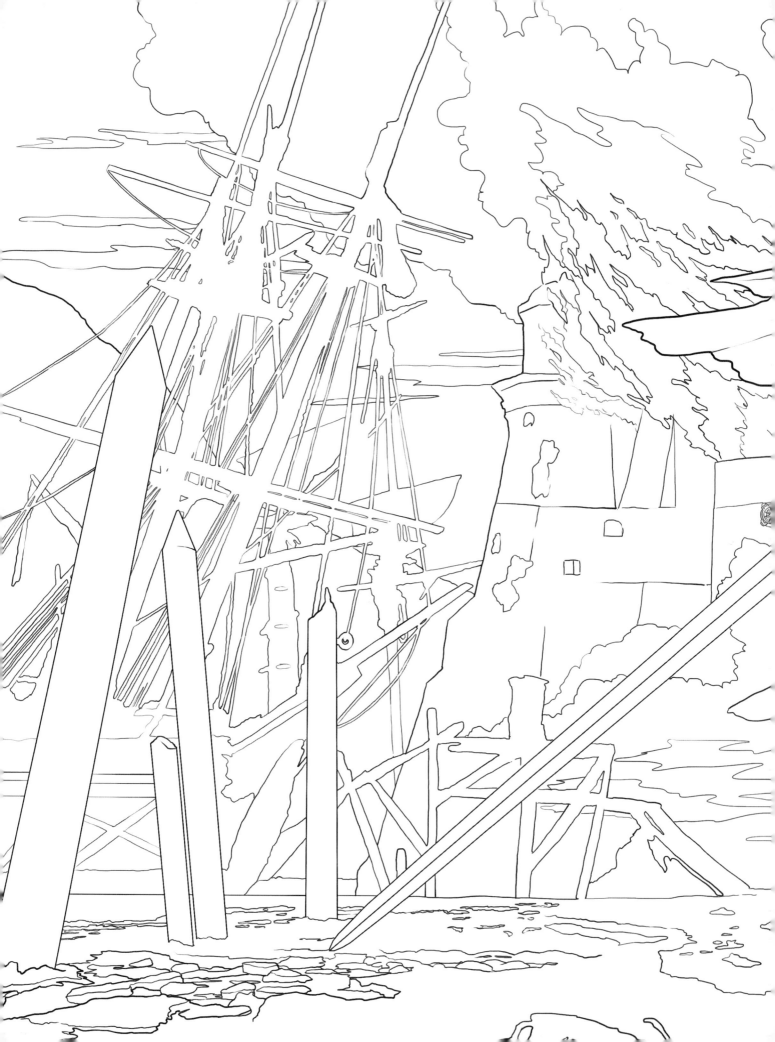

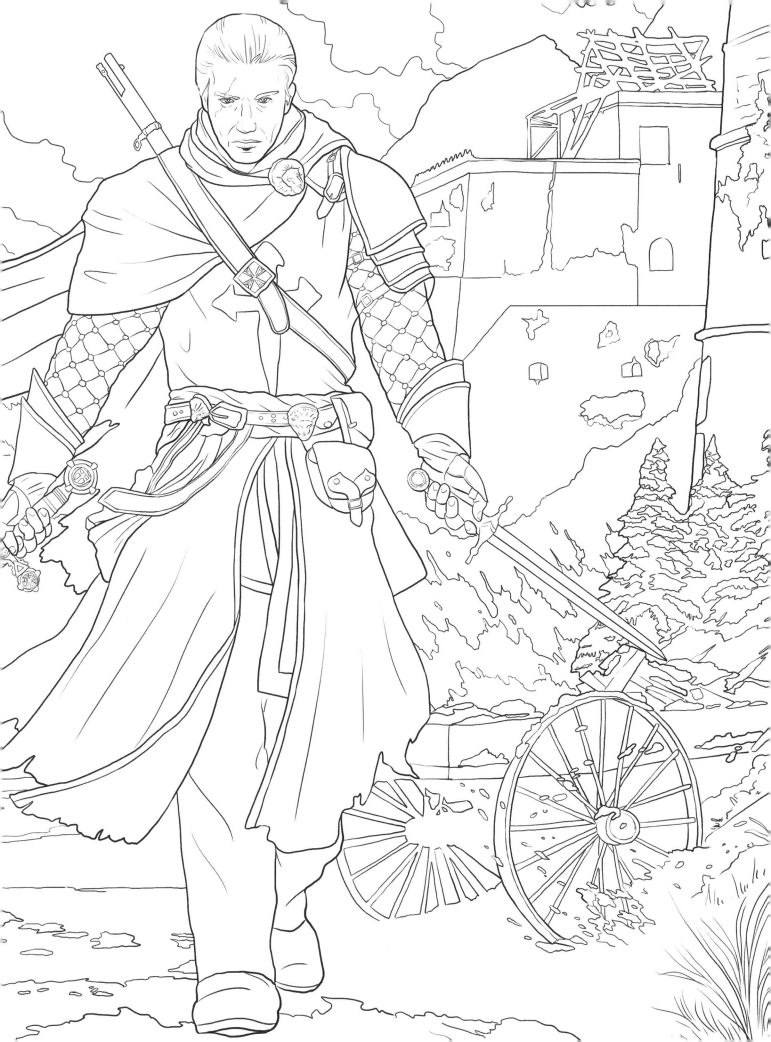

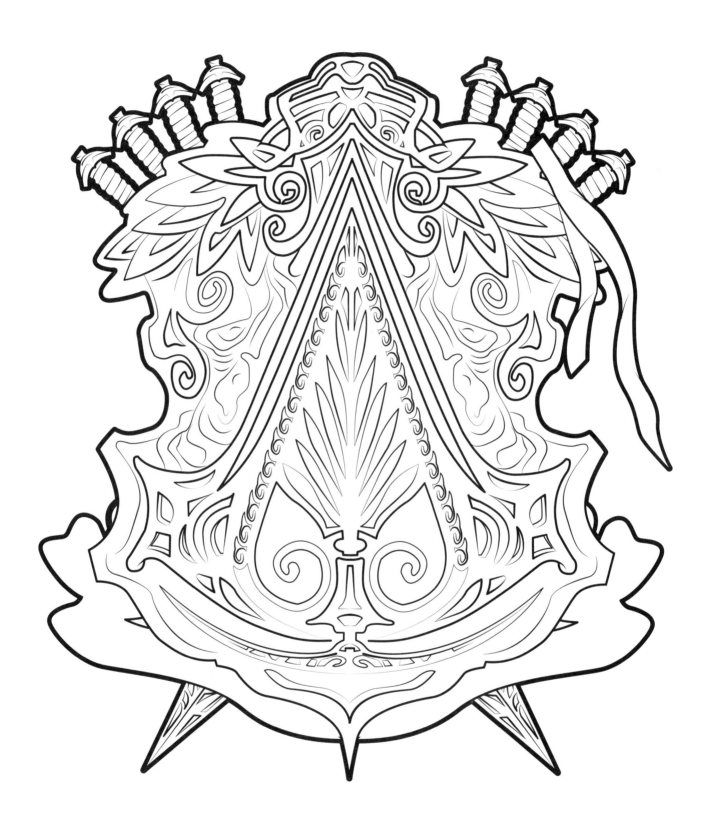

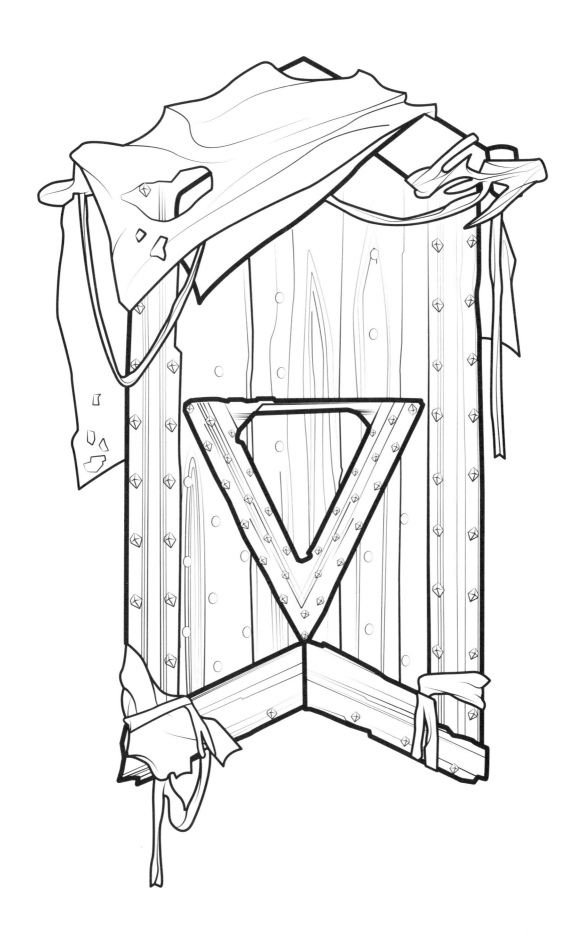

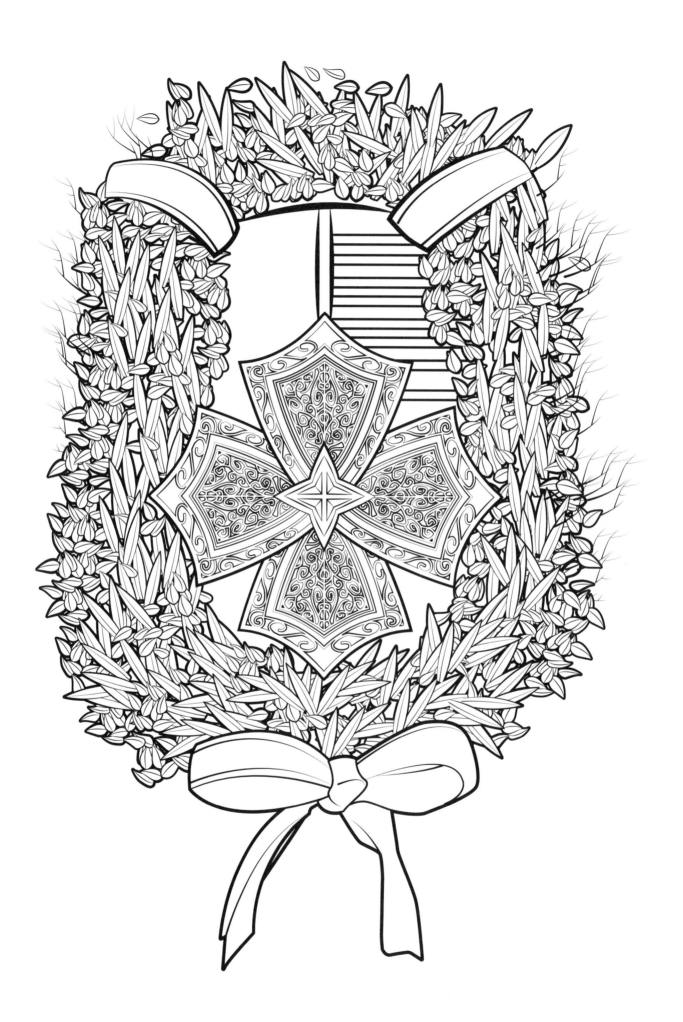

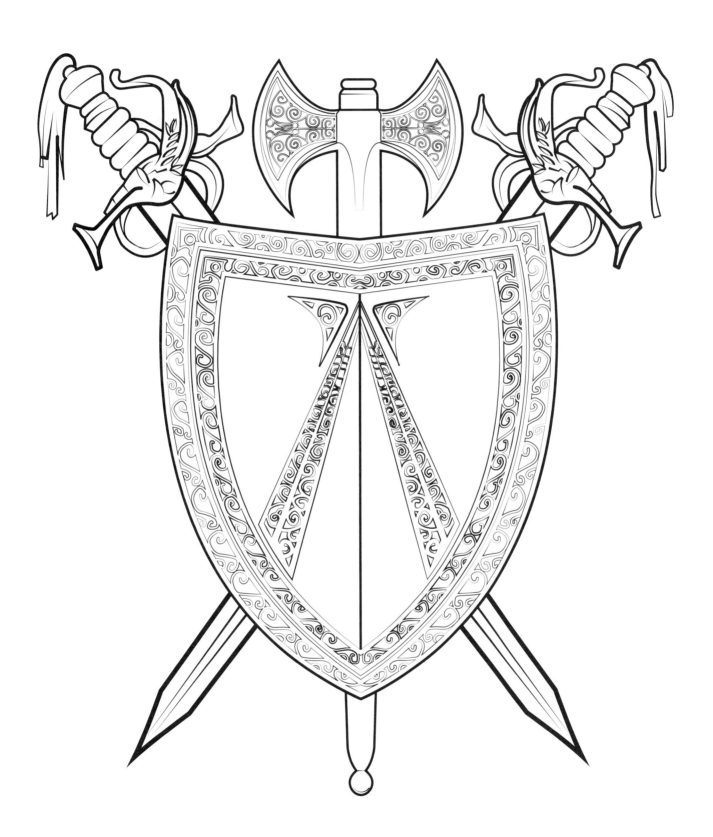

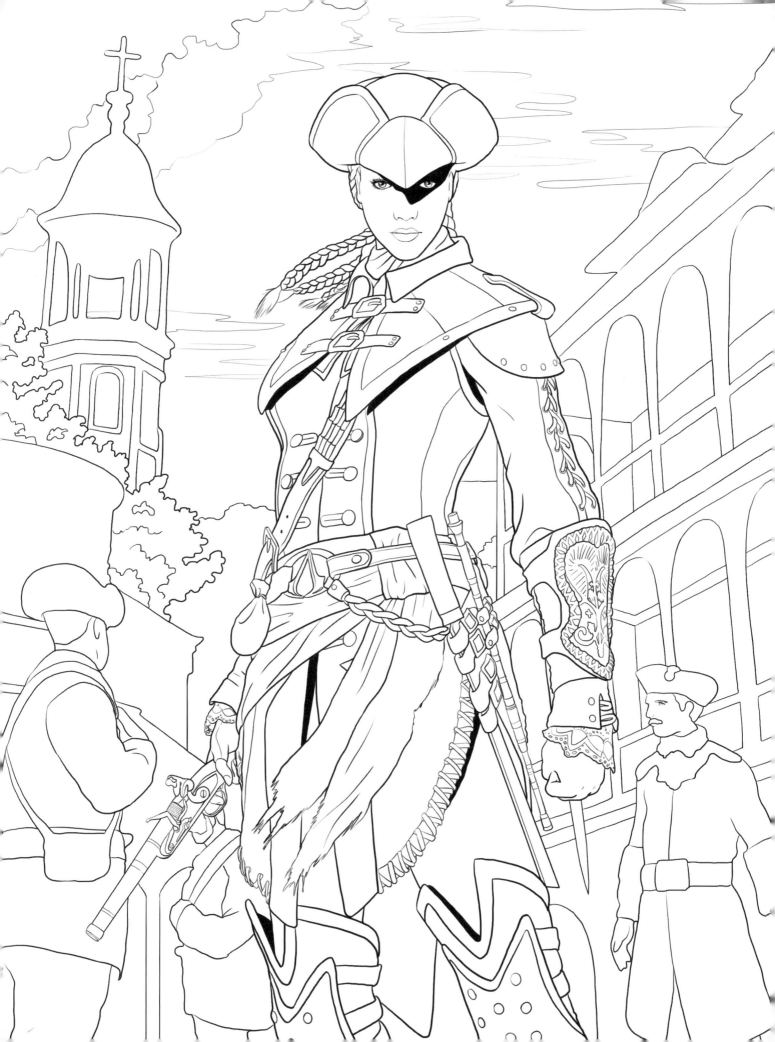

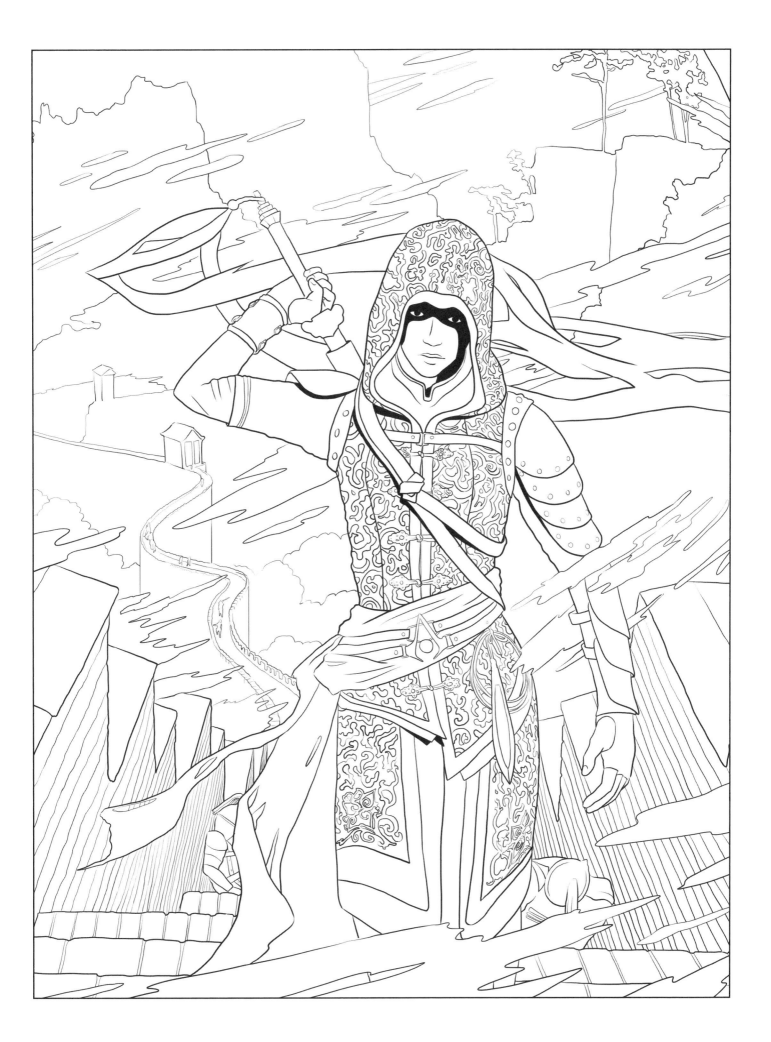

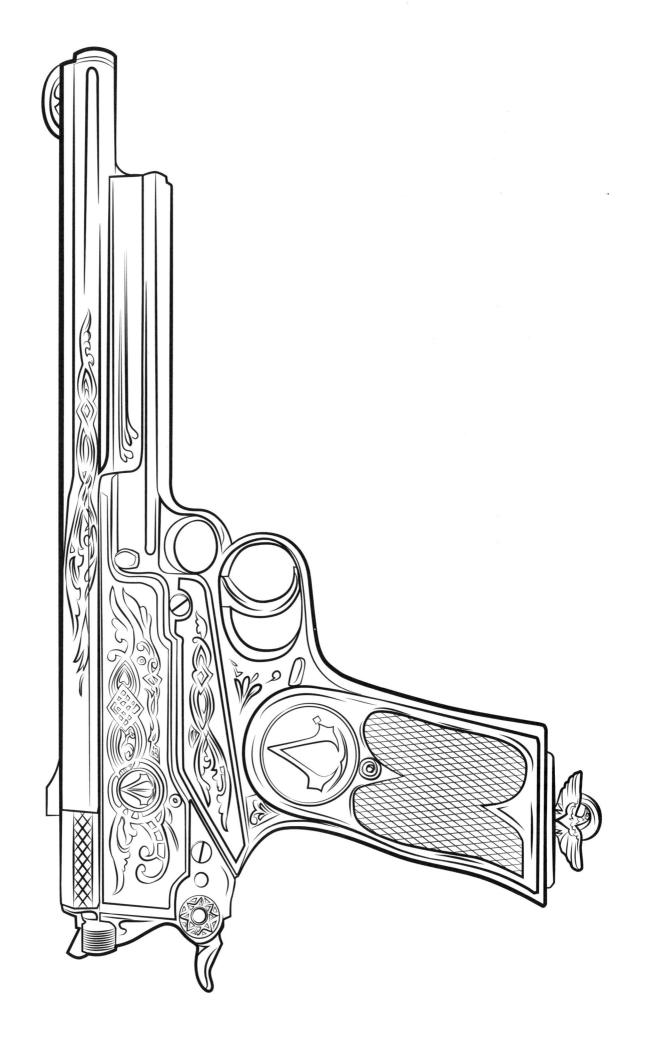

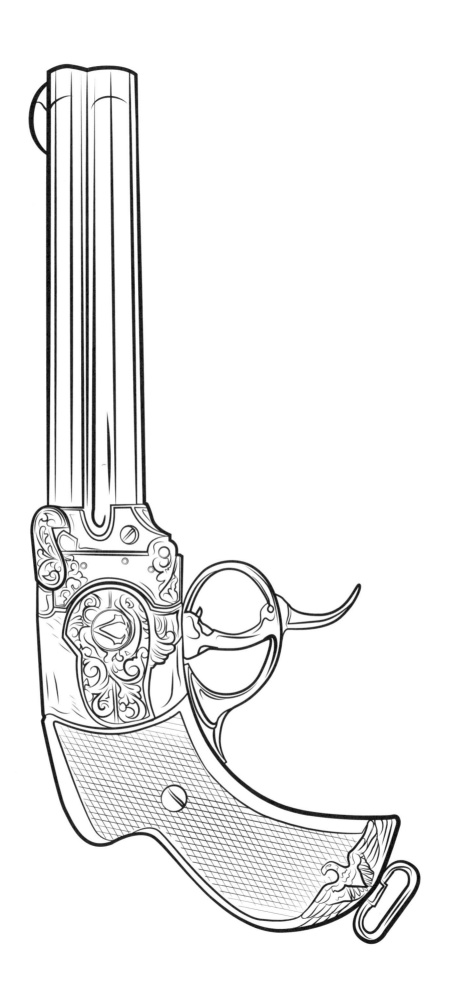

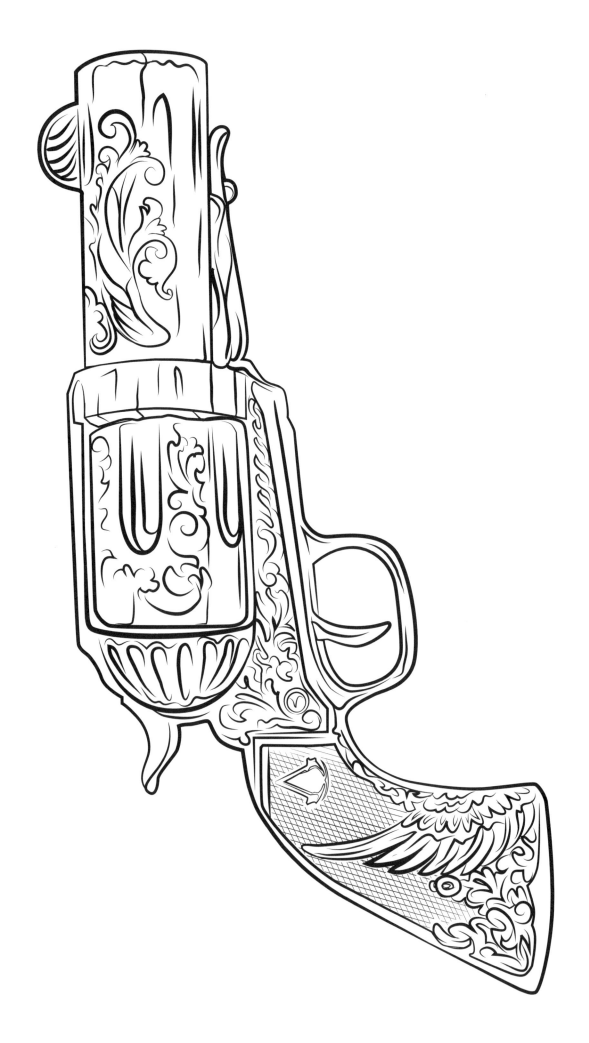

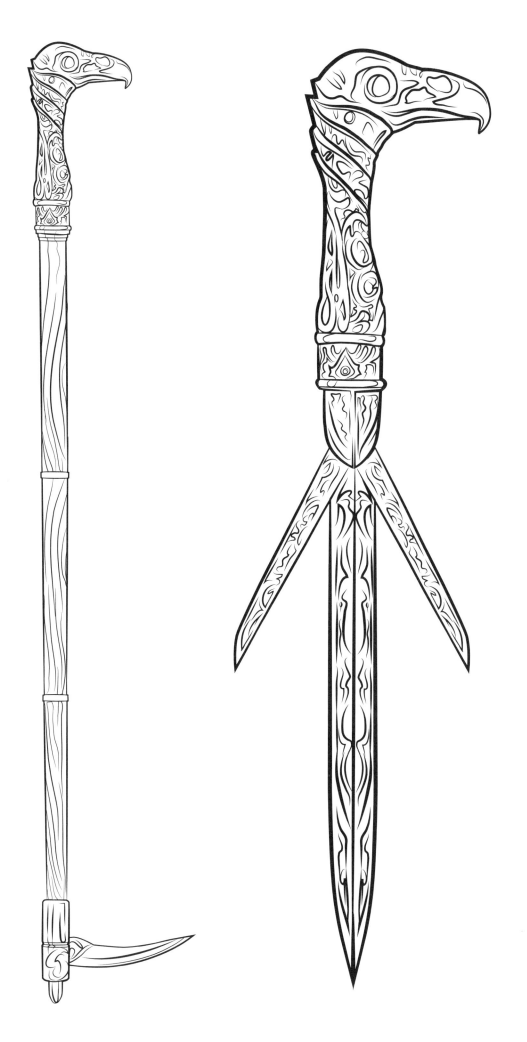

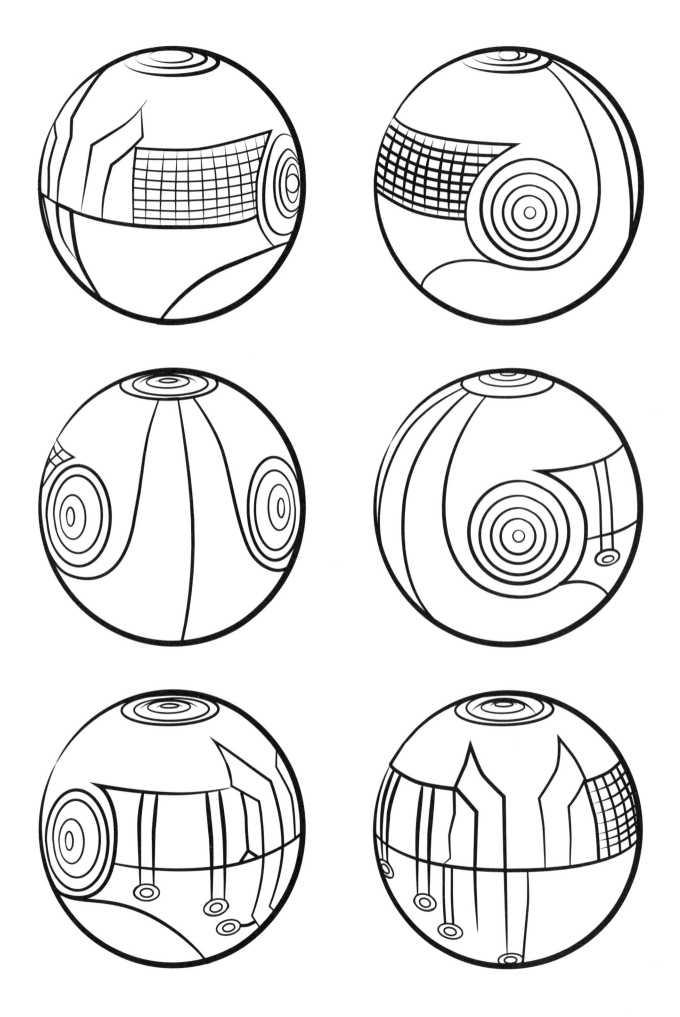

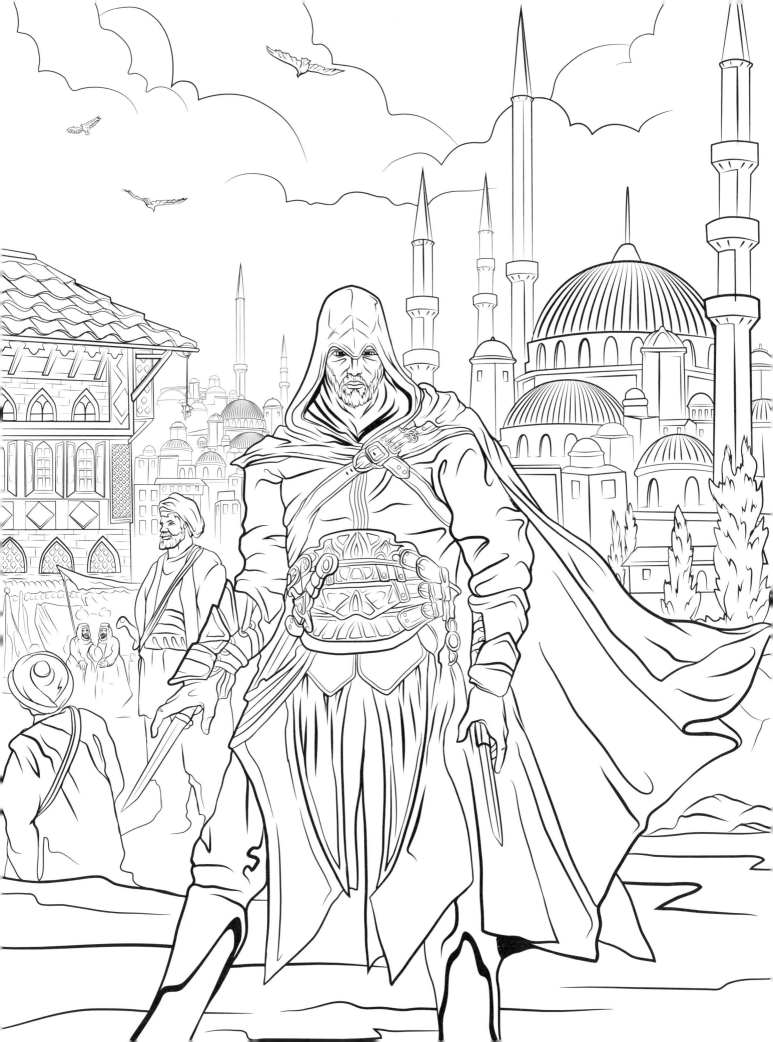

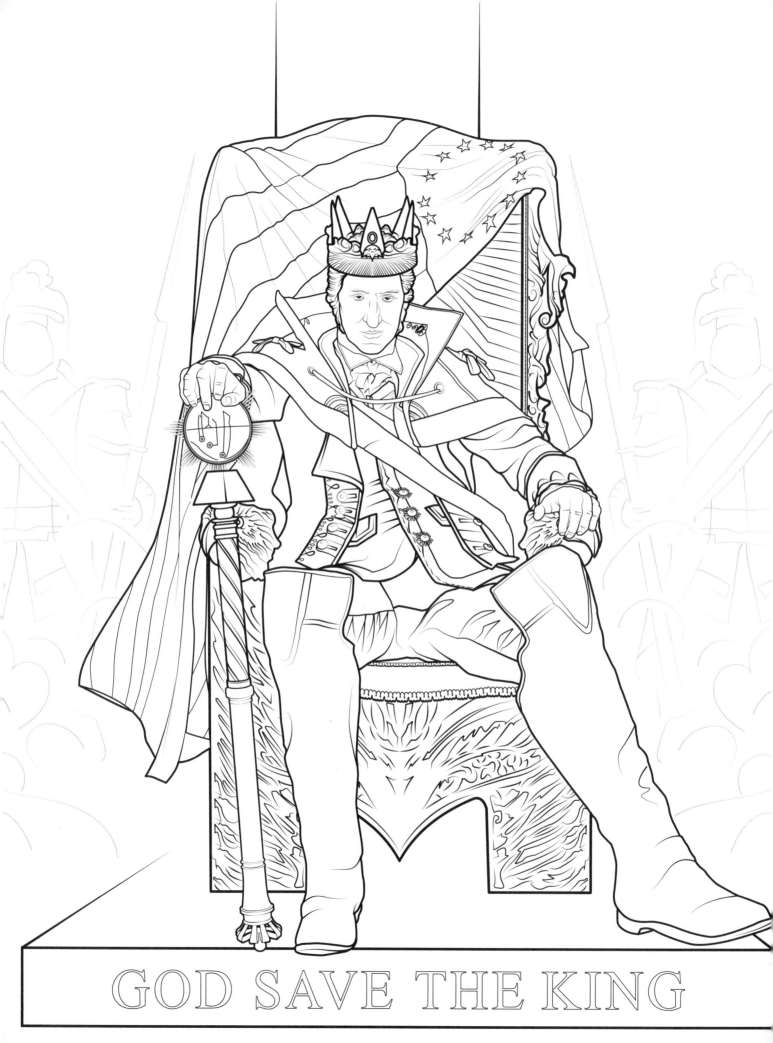

GOD SAVE THE KING

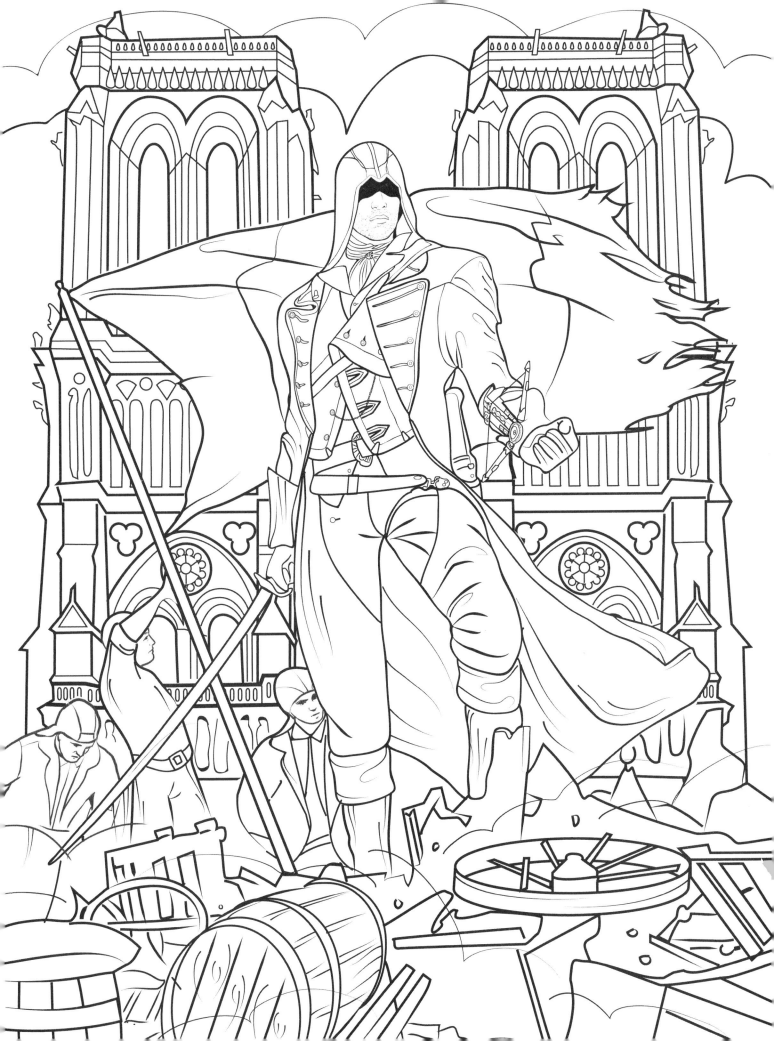

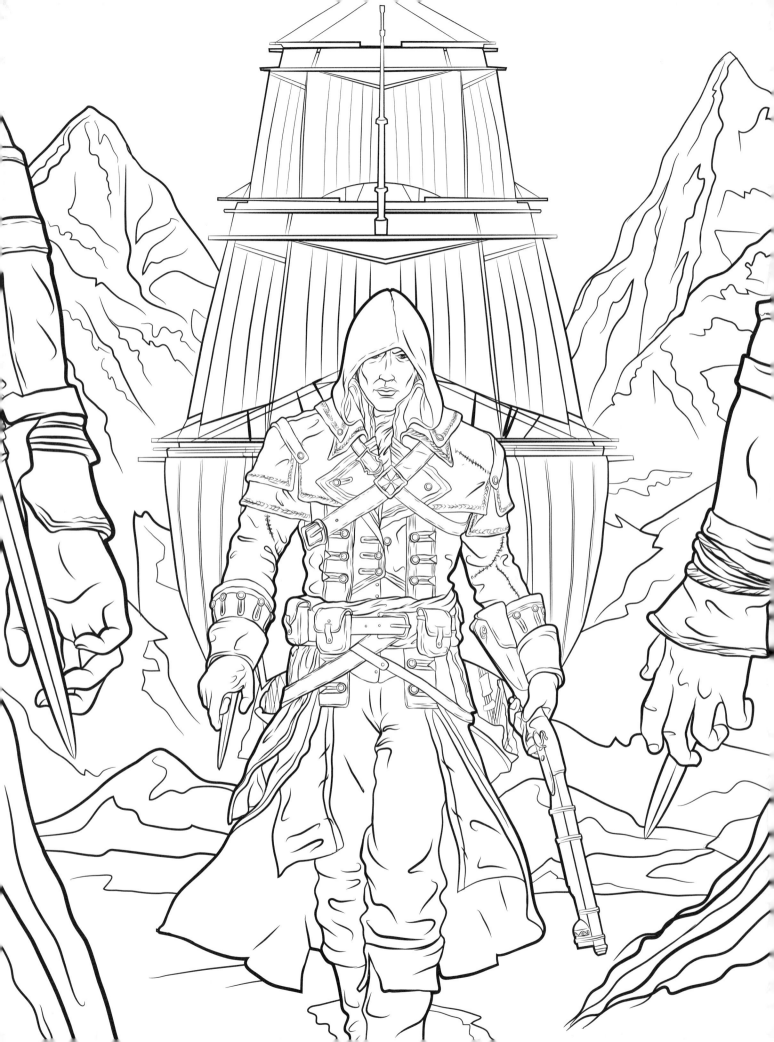

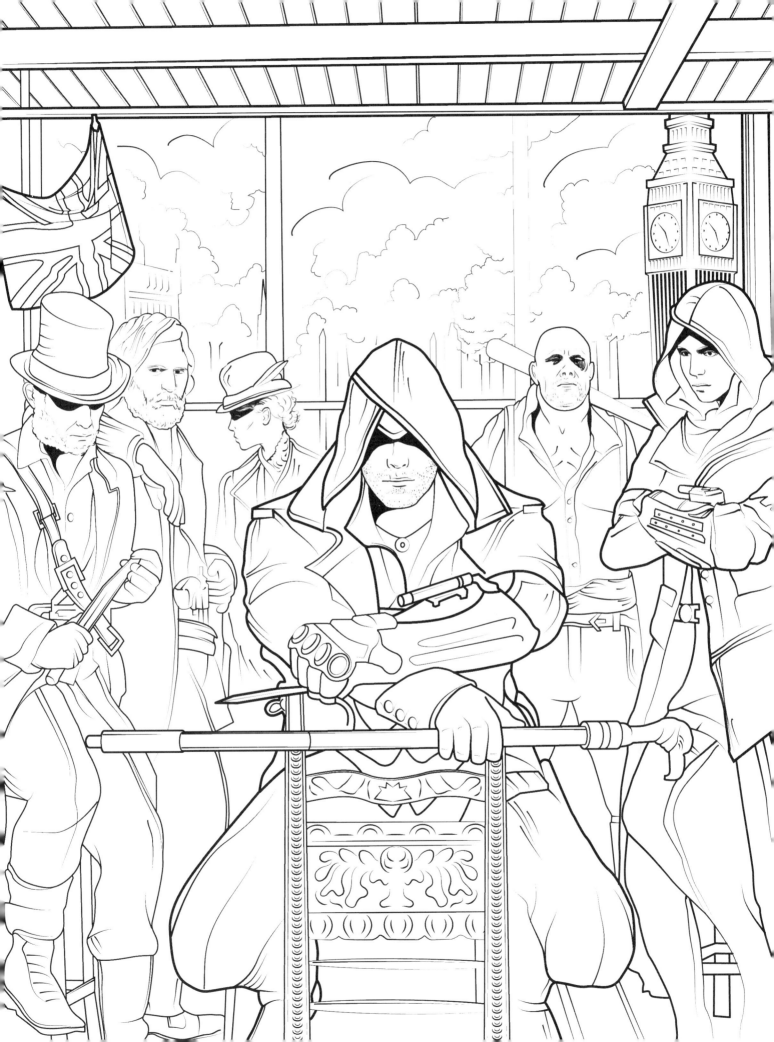

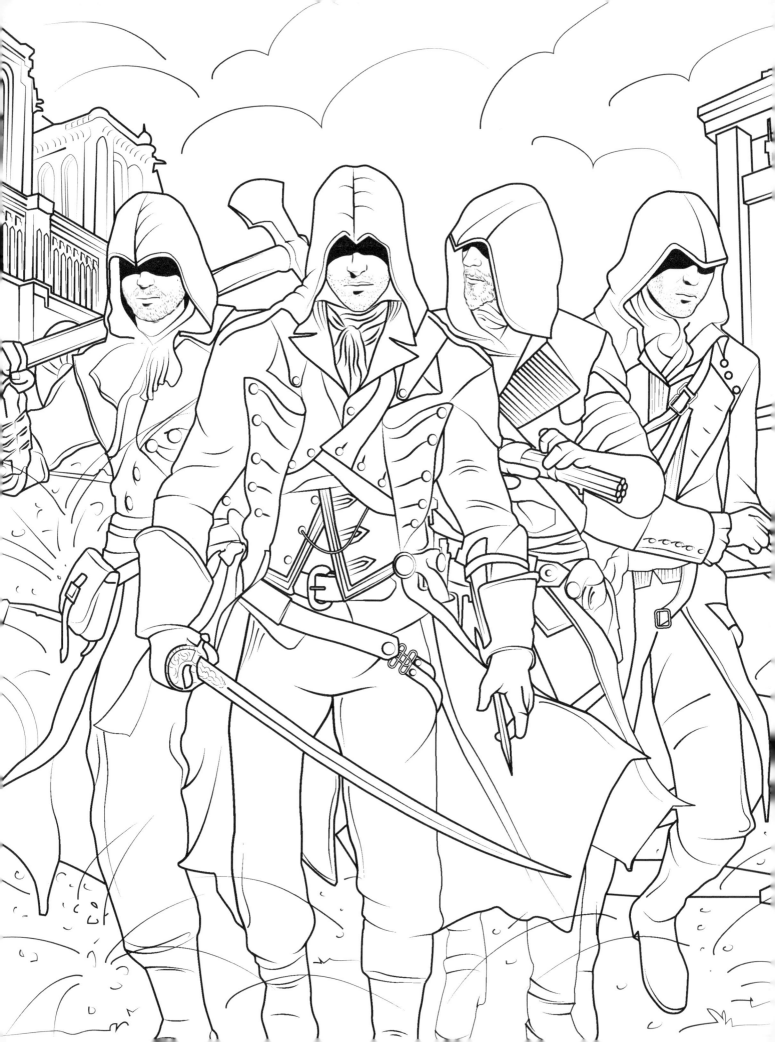

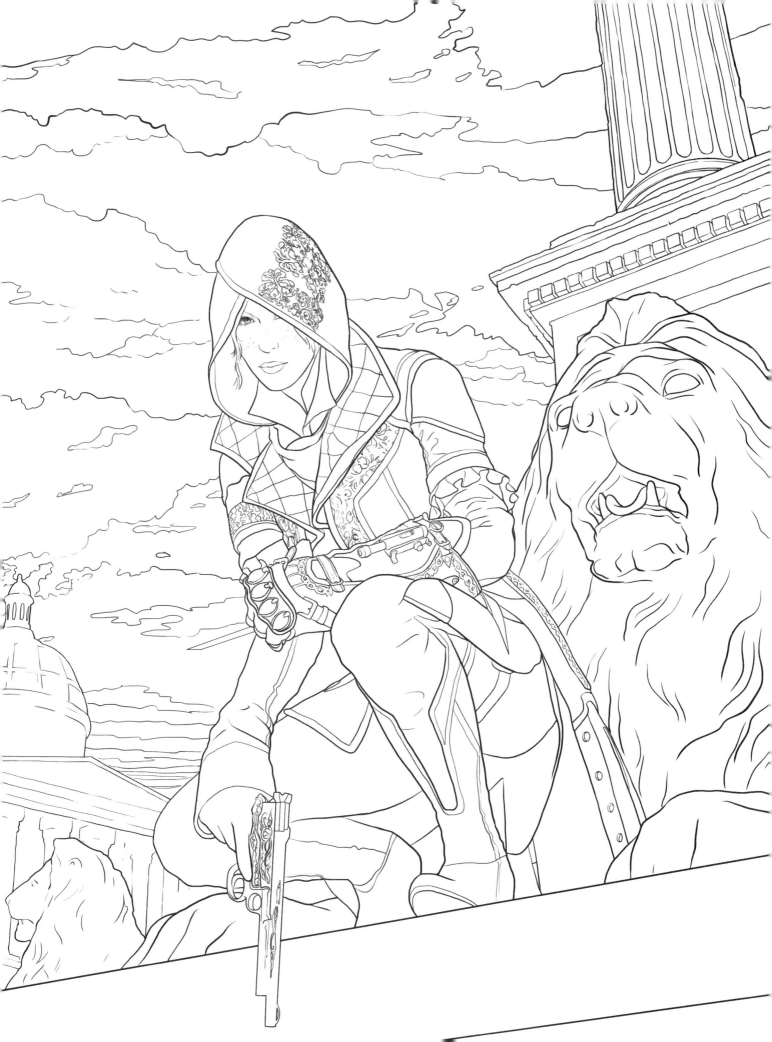

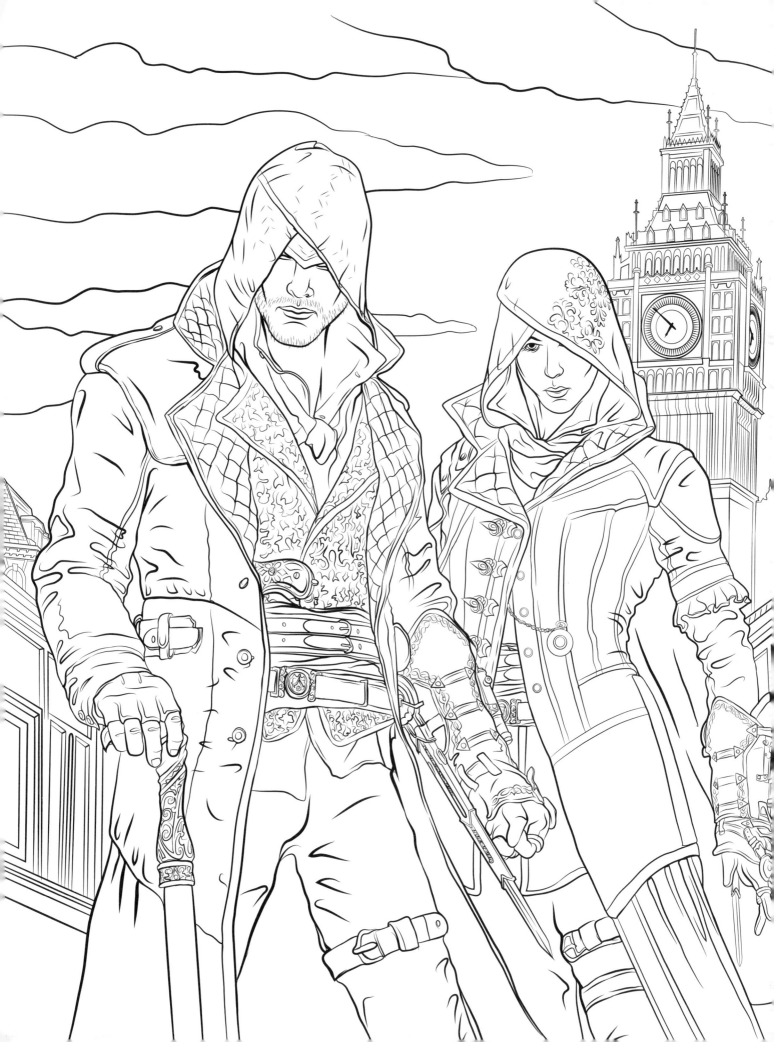

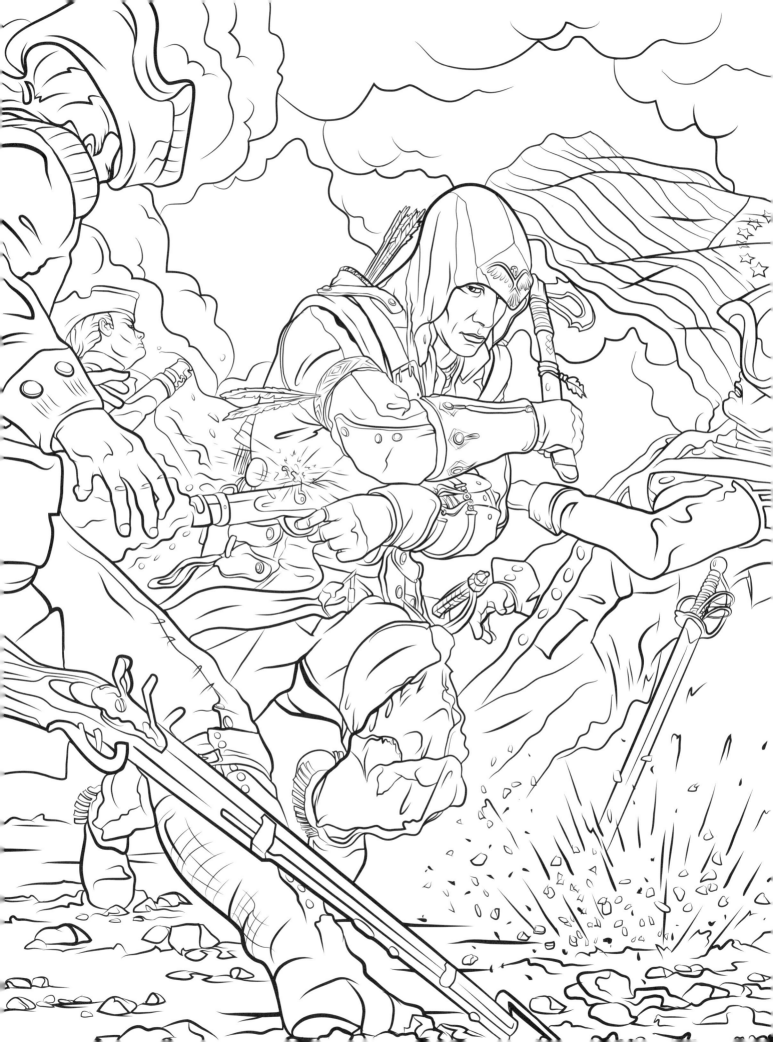

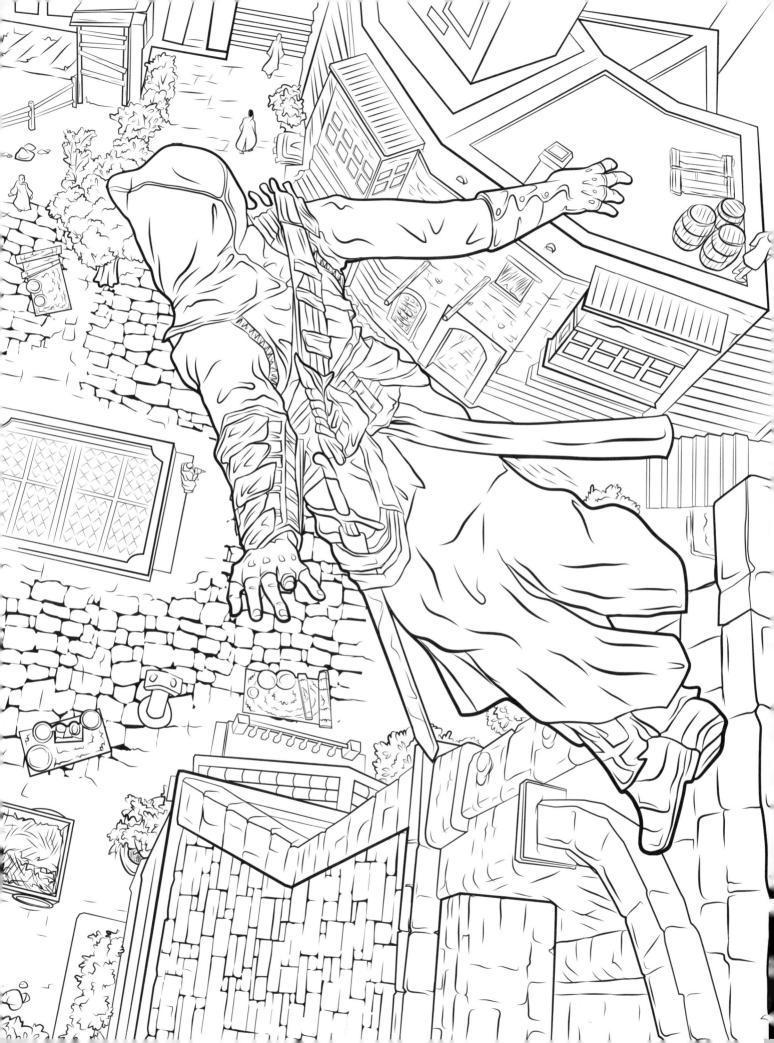

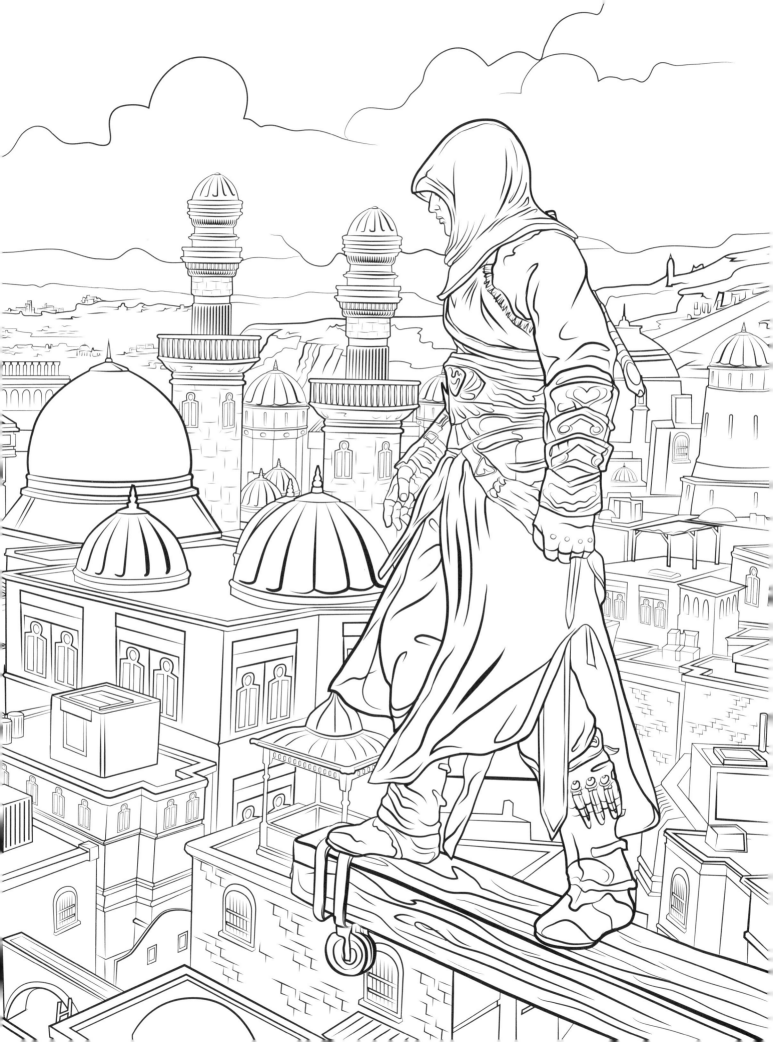

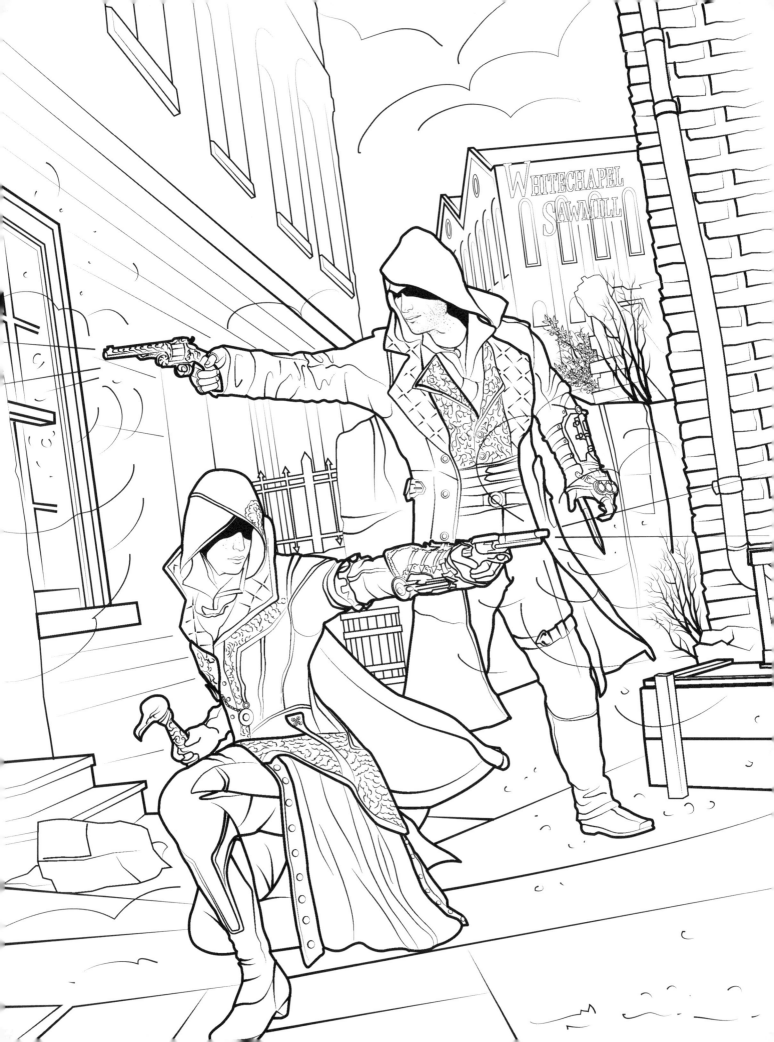

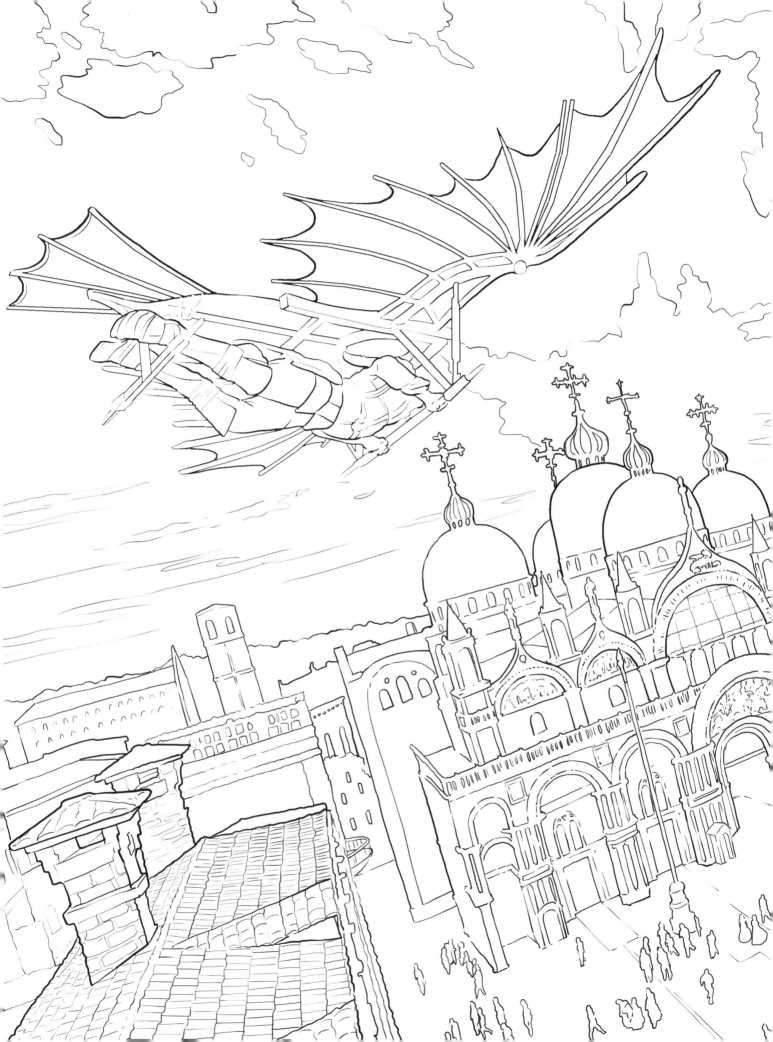

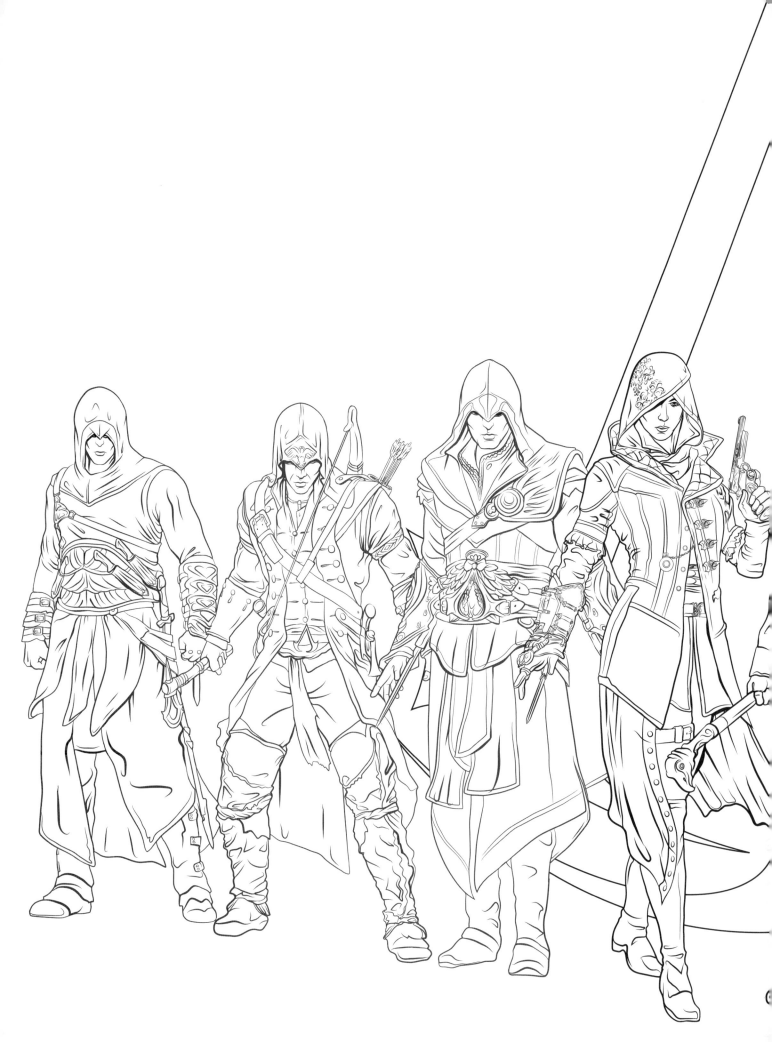

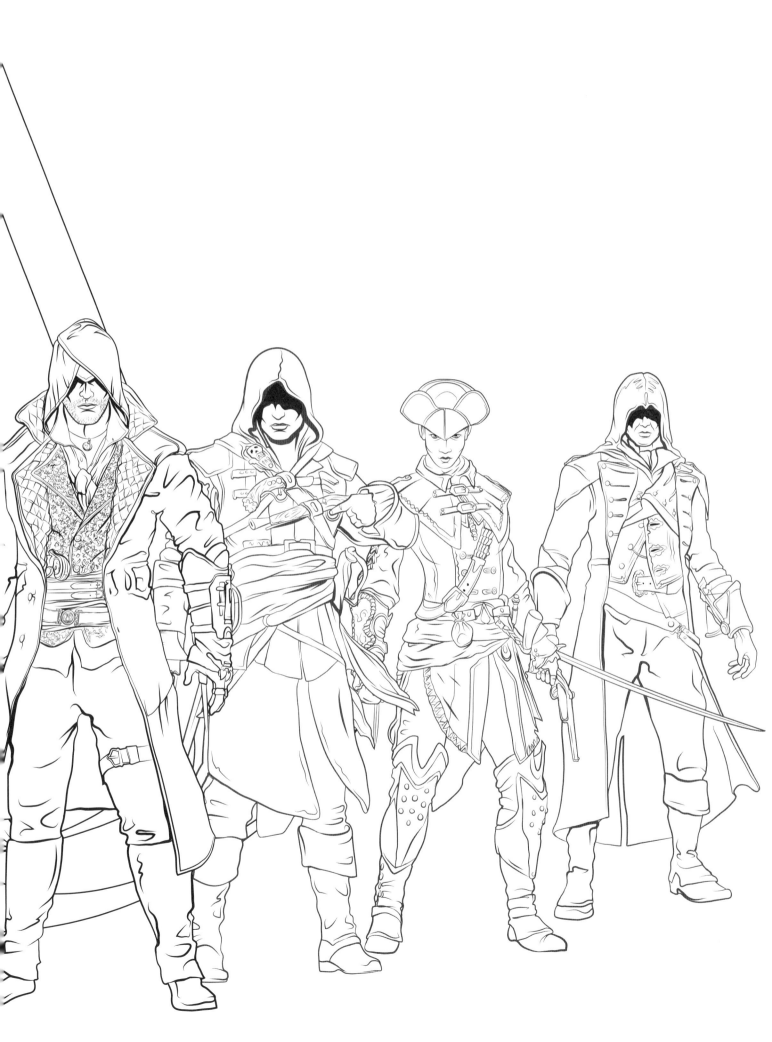

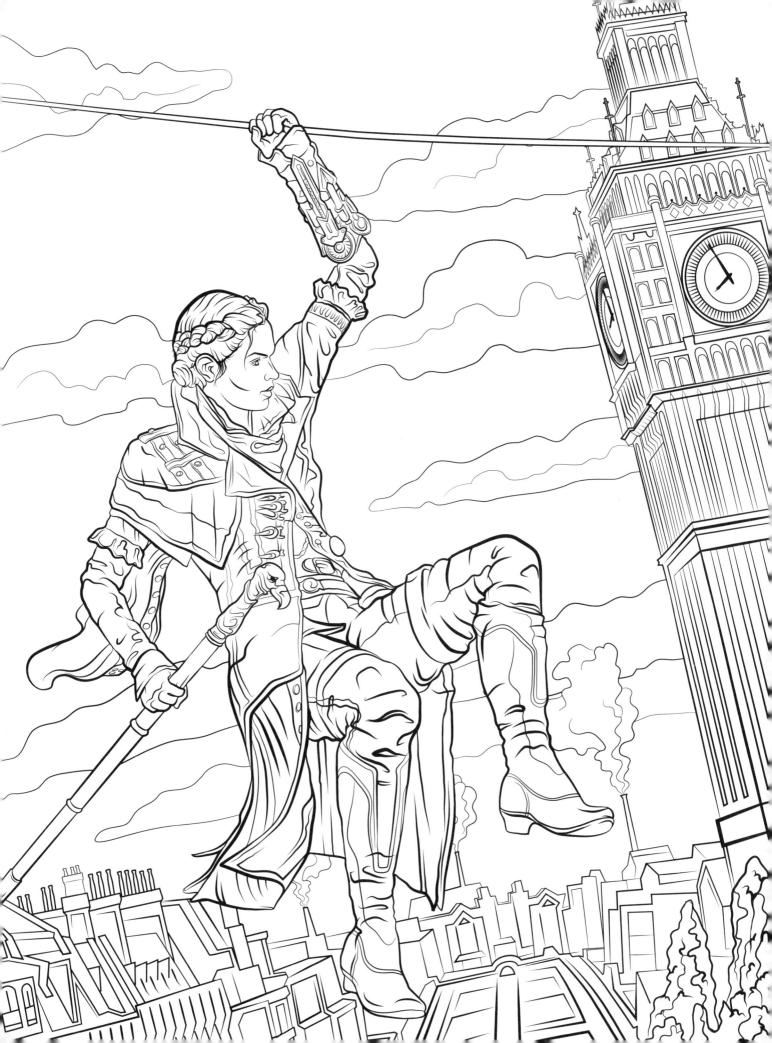

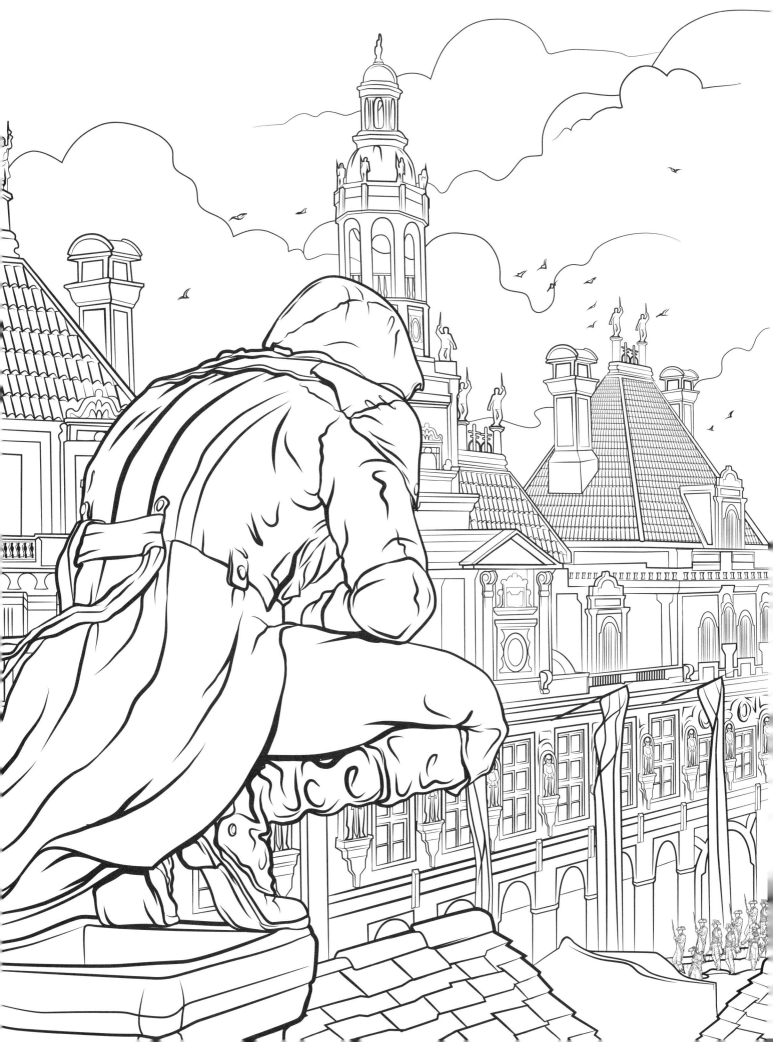

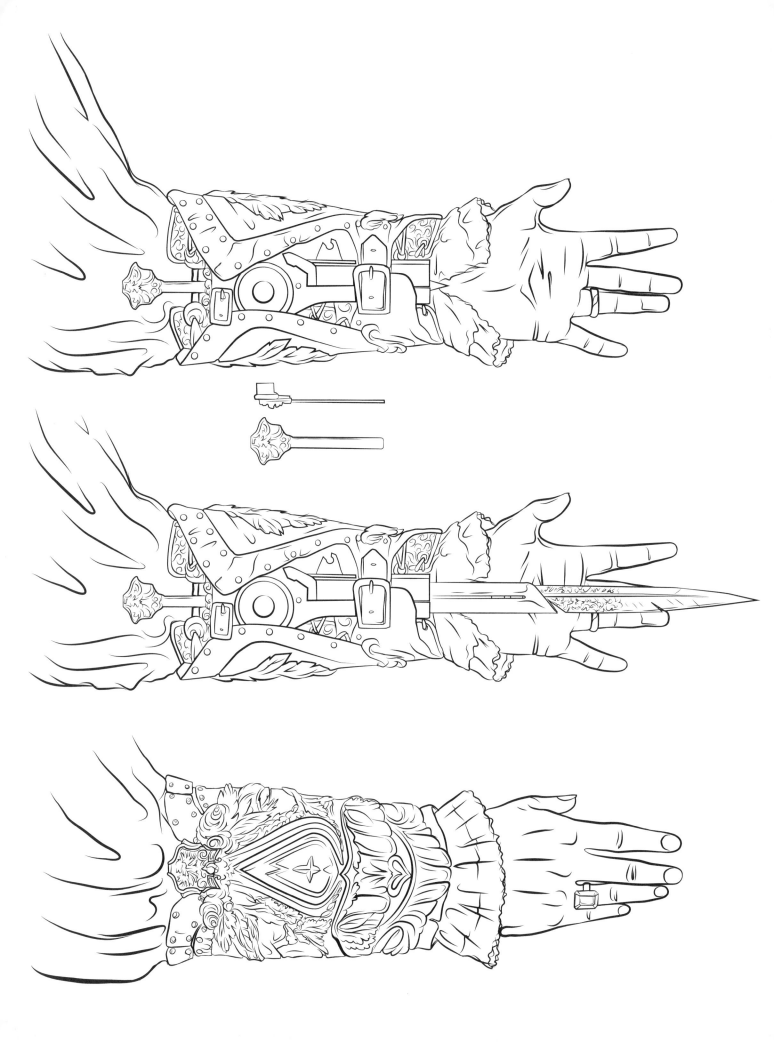

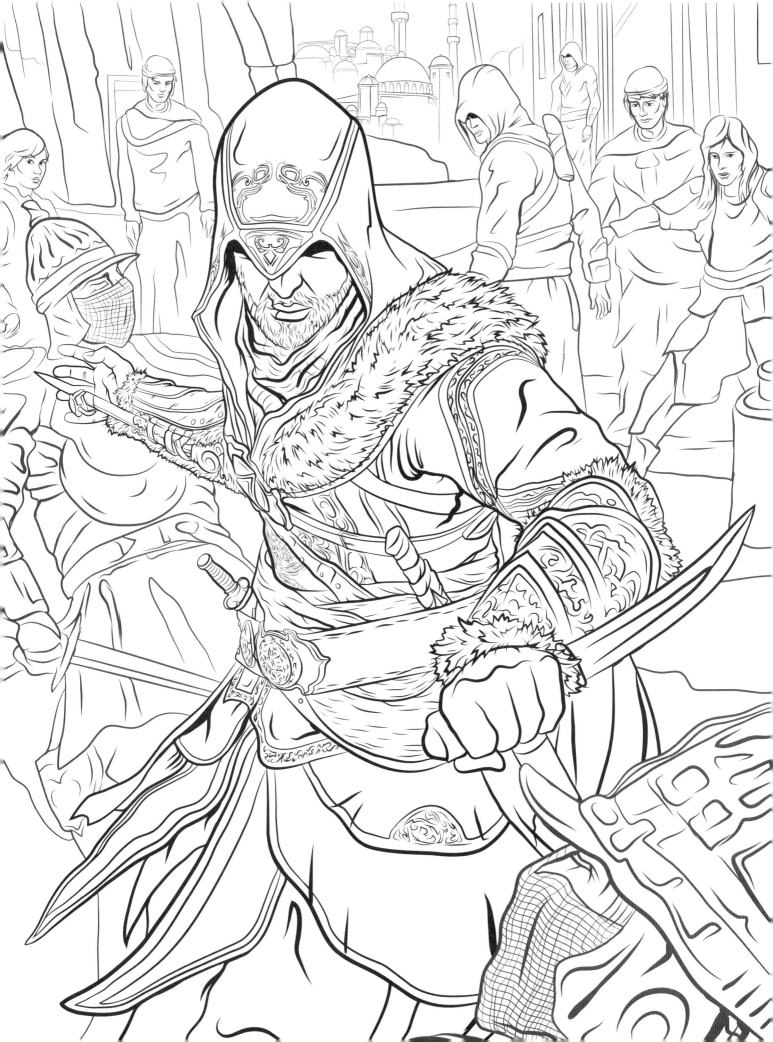

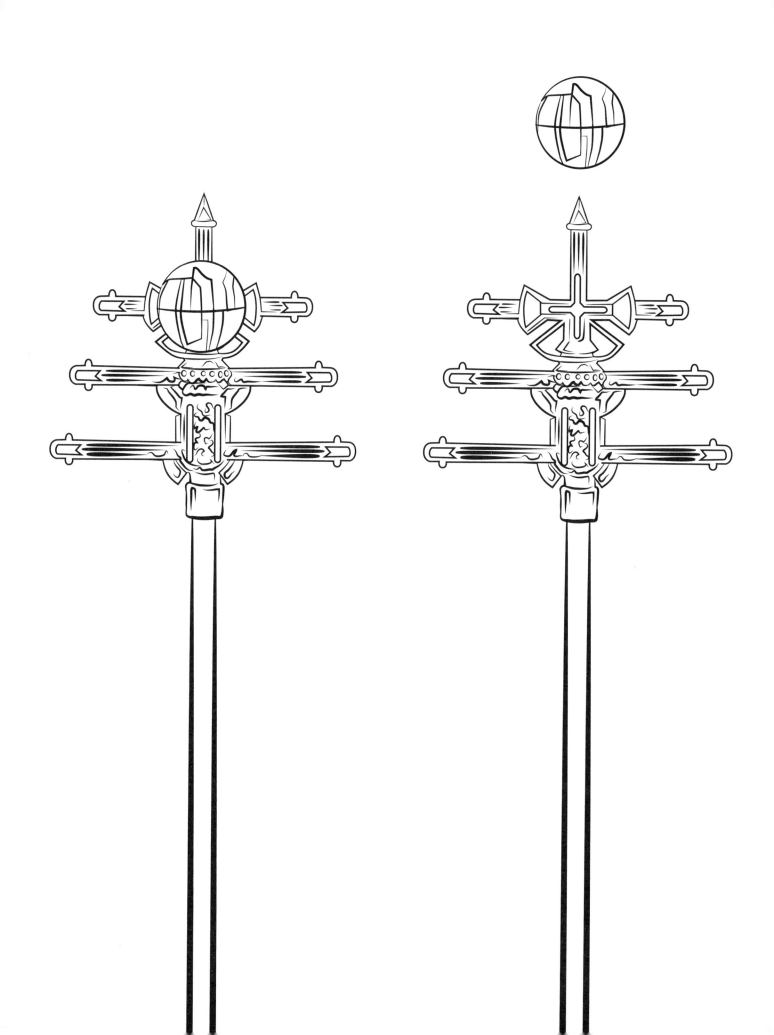

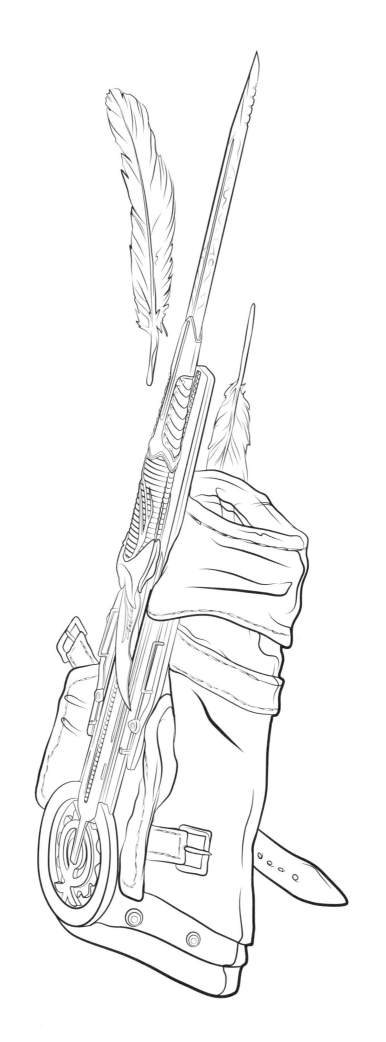

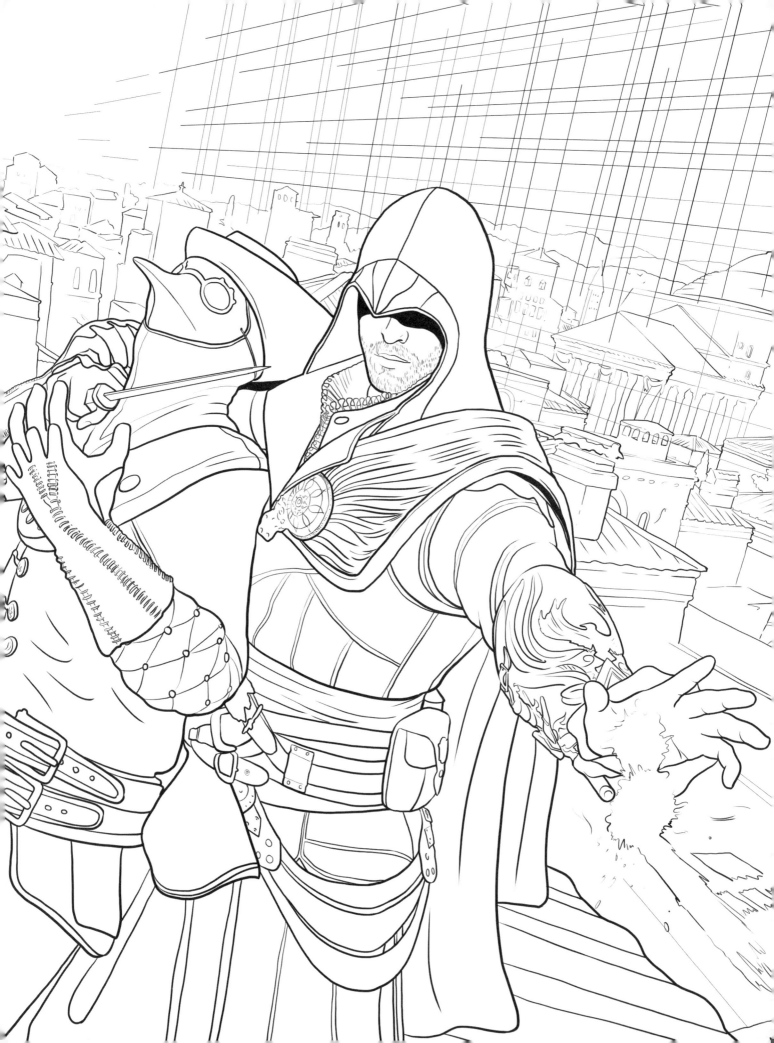

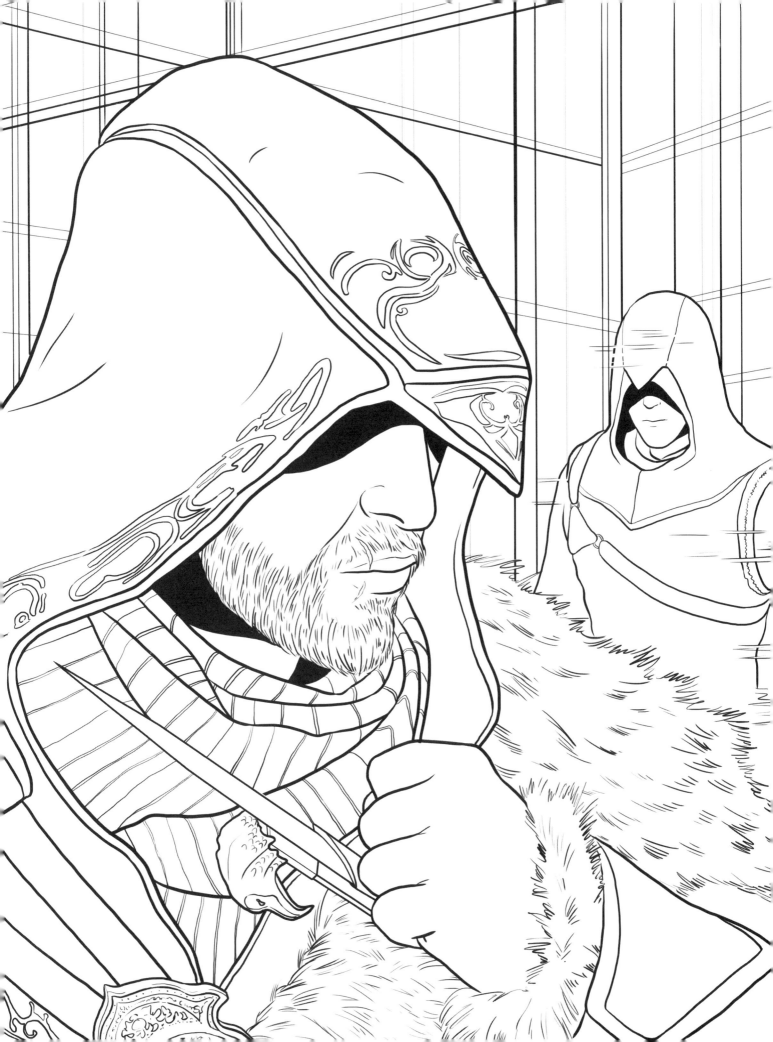

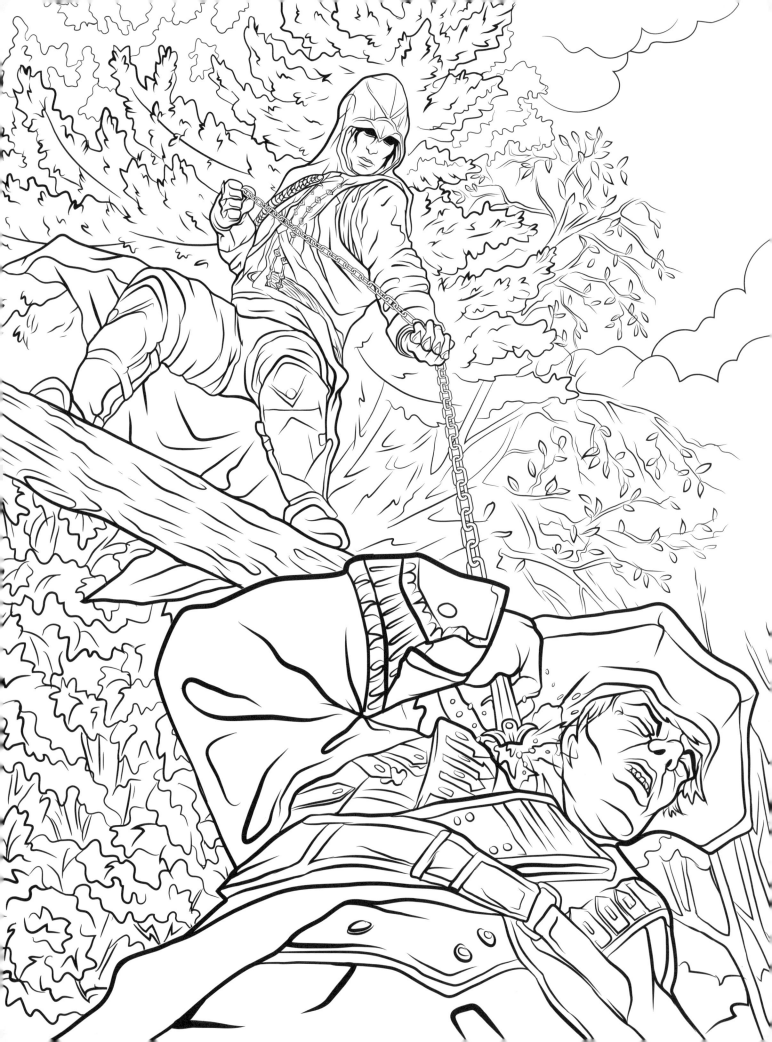

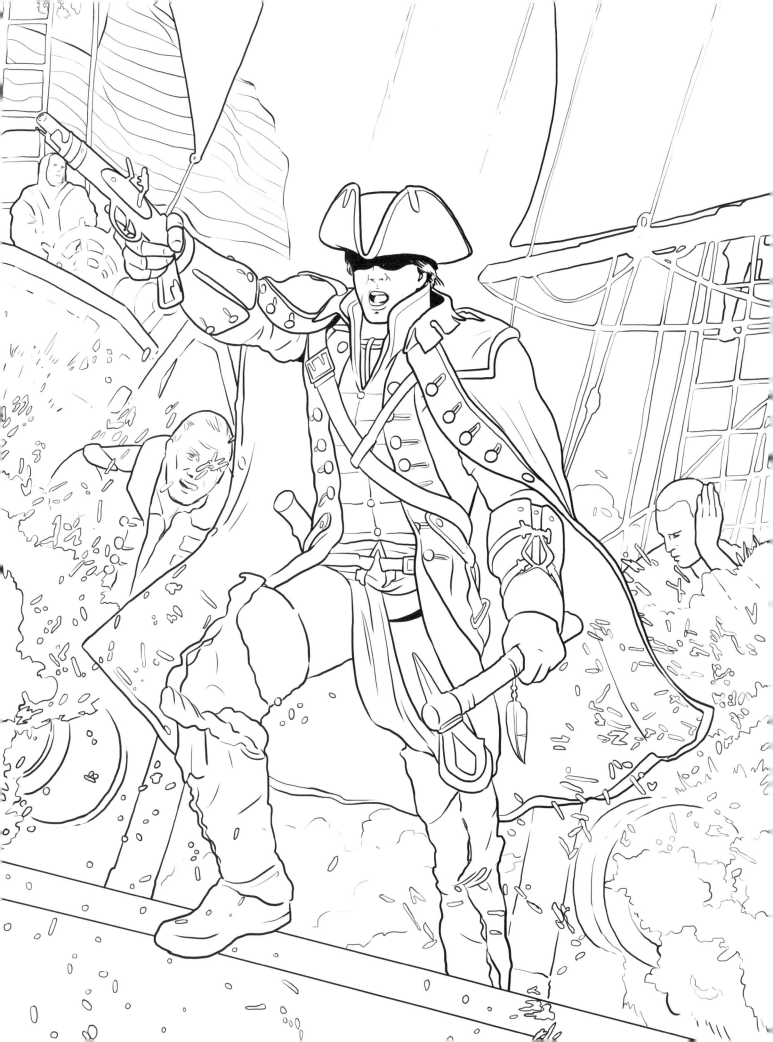

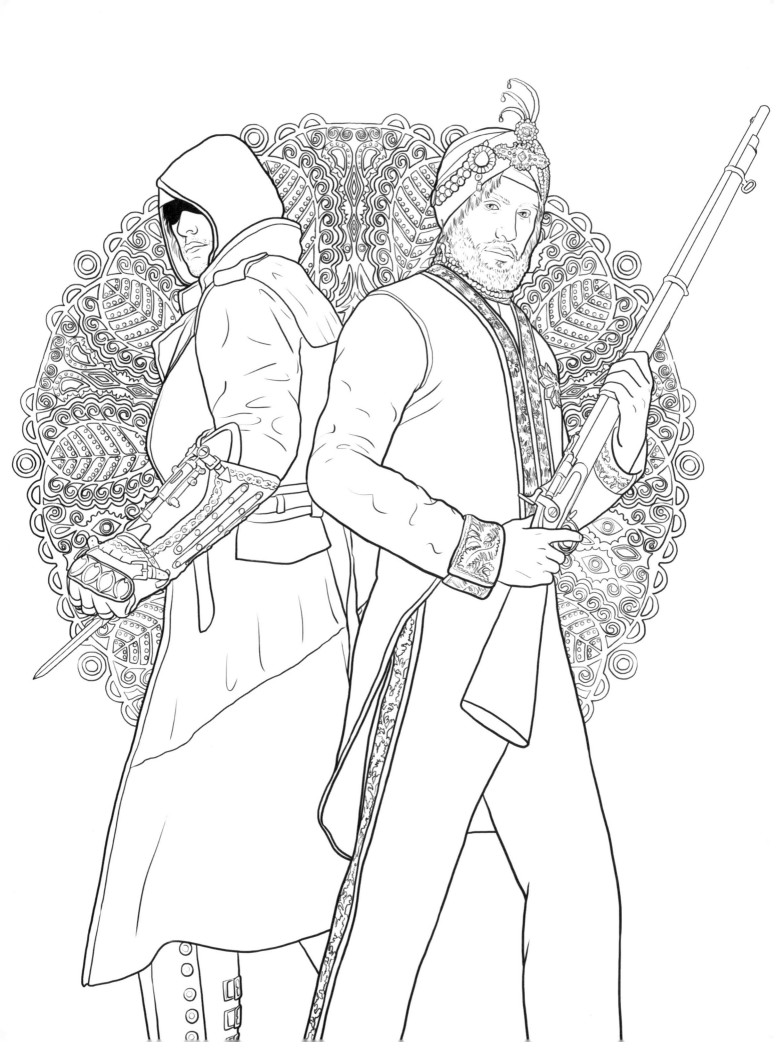

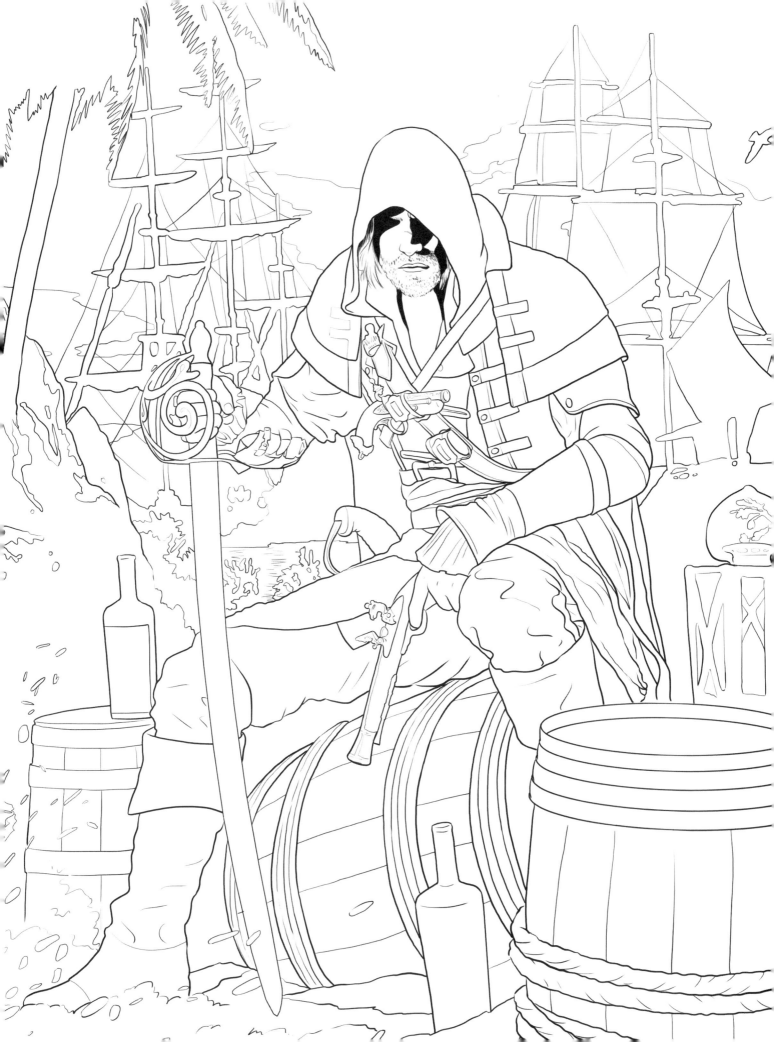

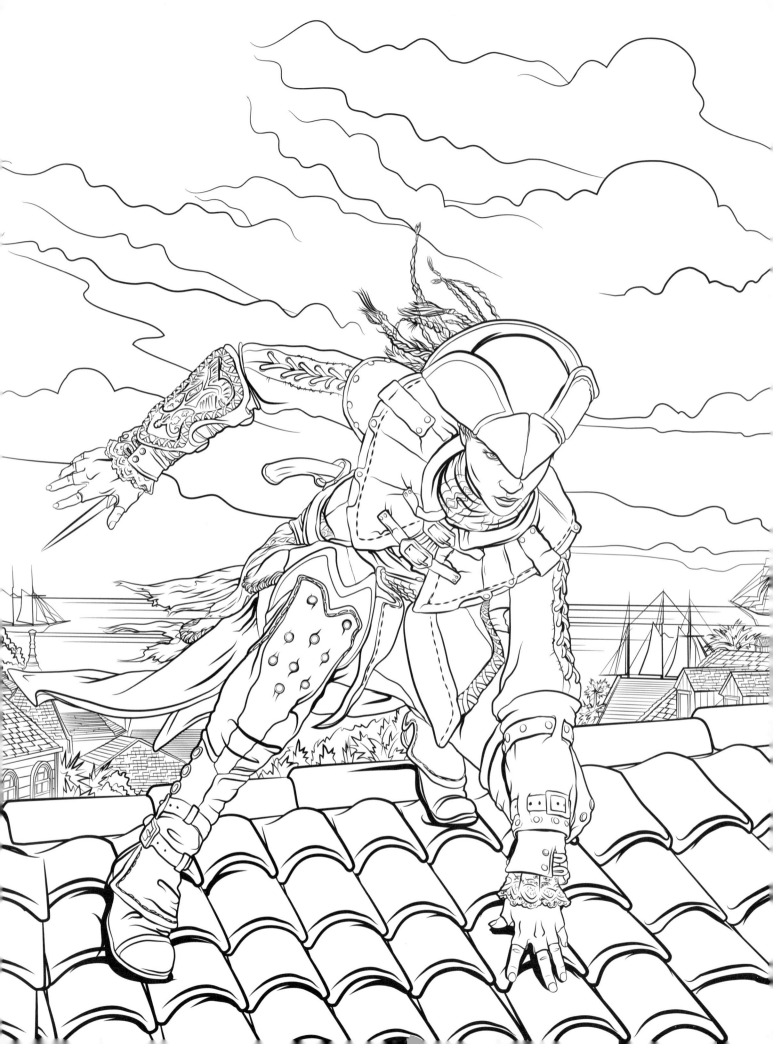

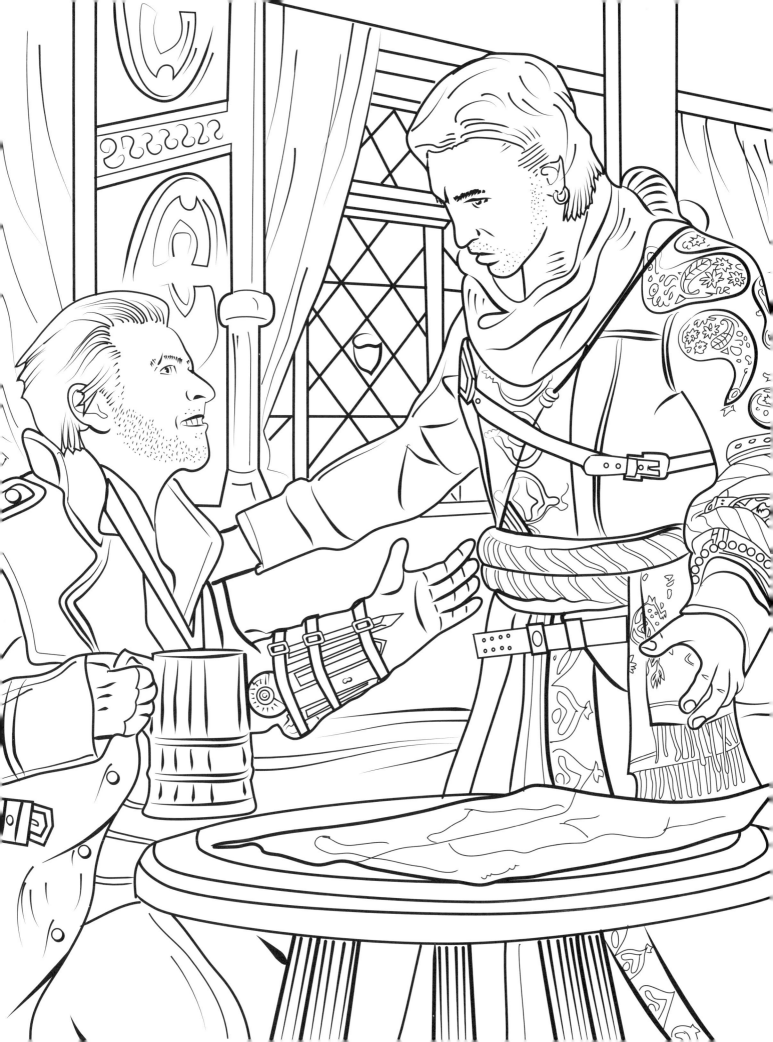

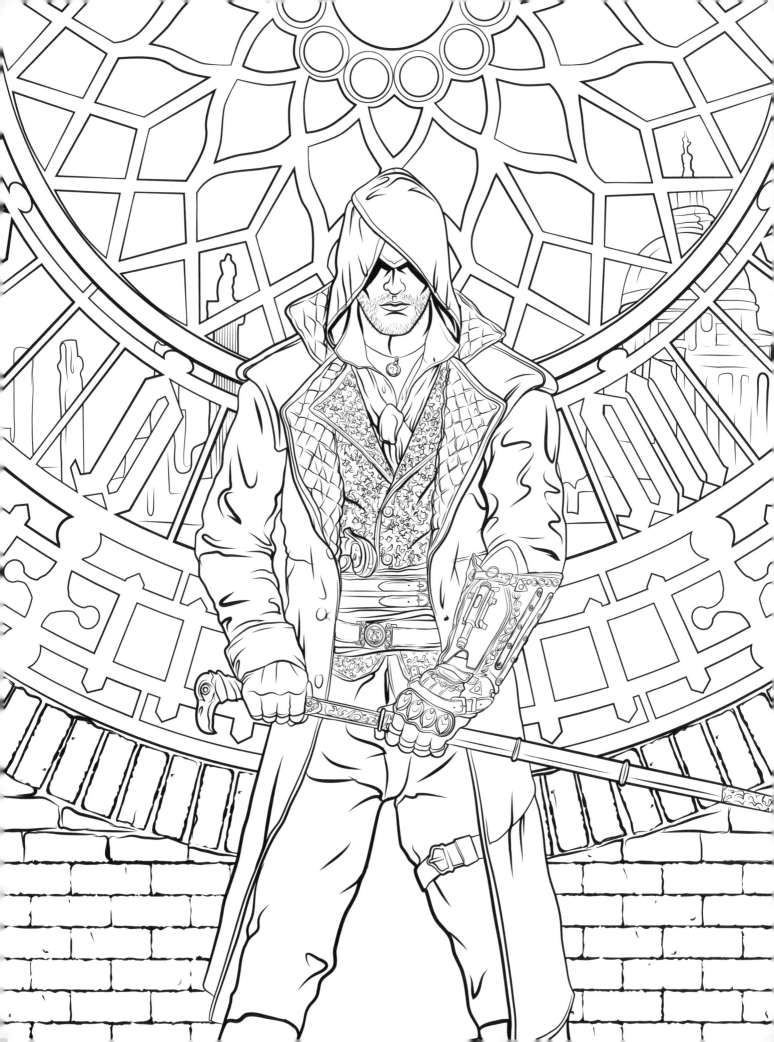

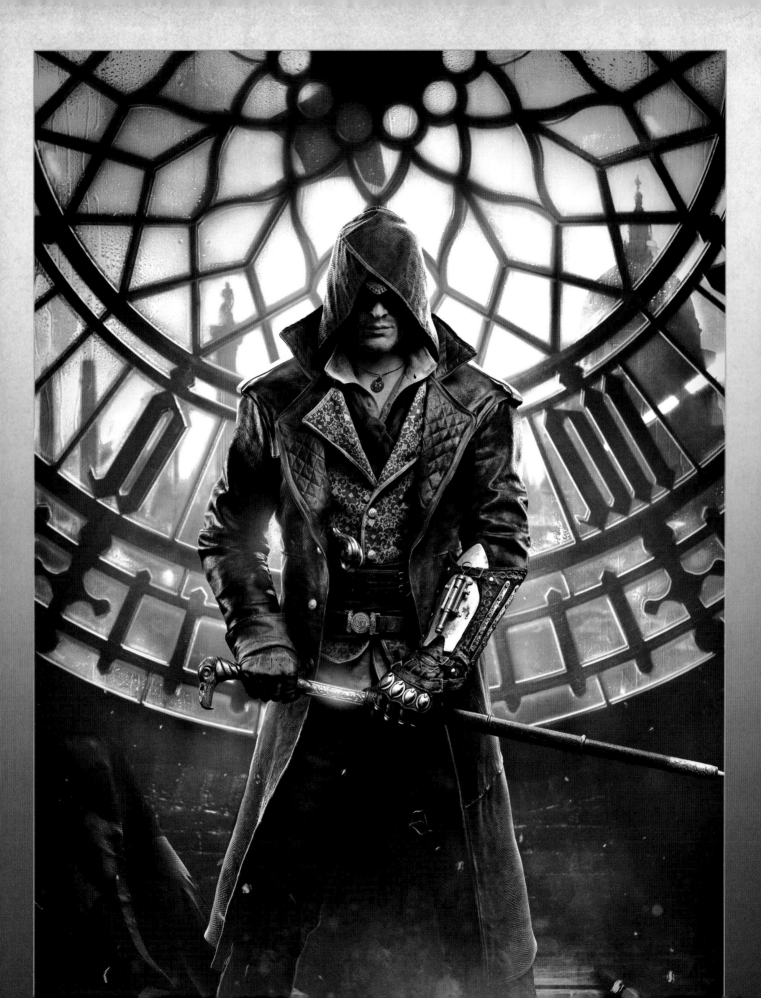

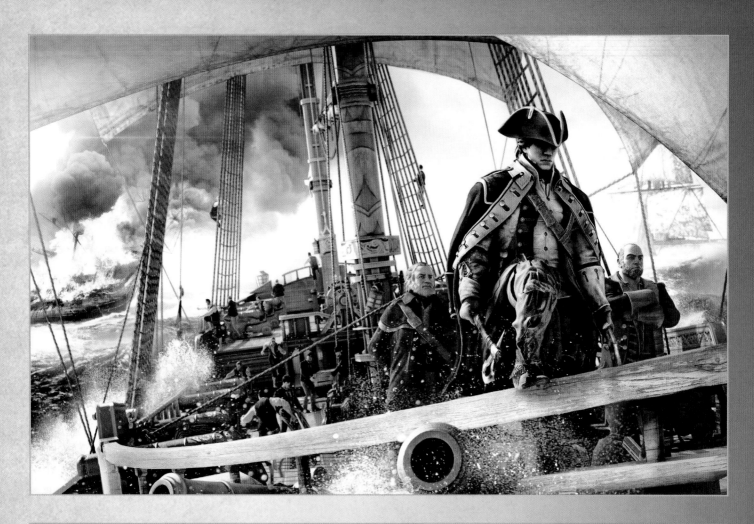

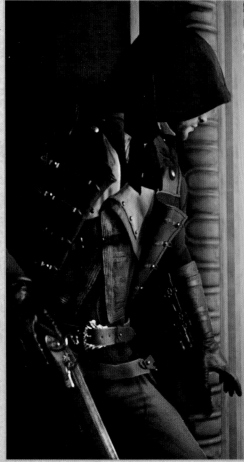

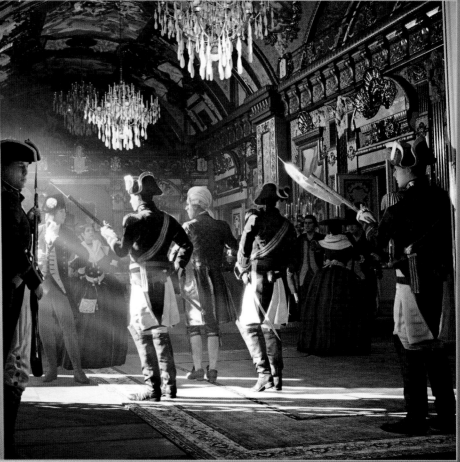

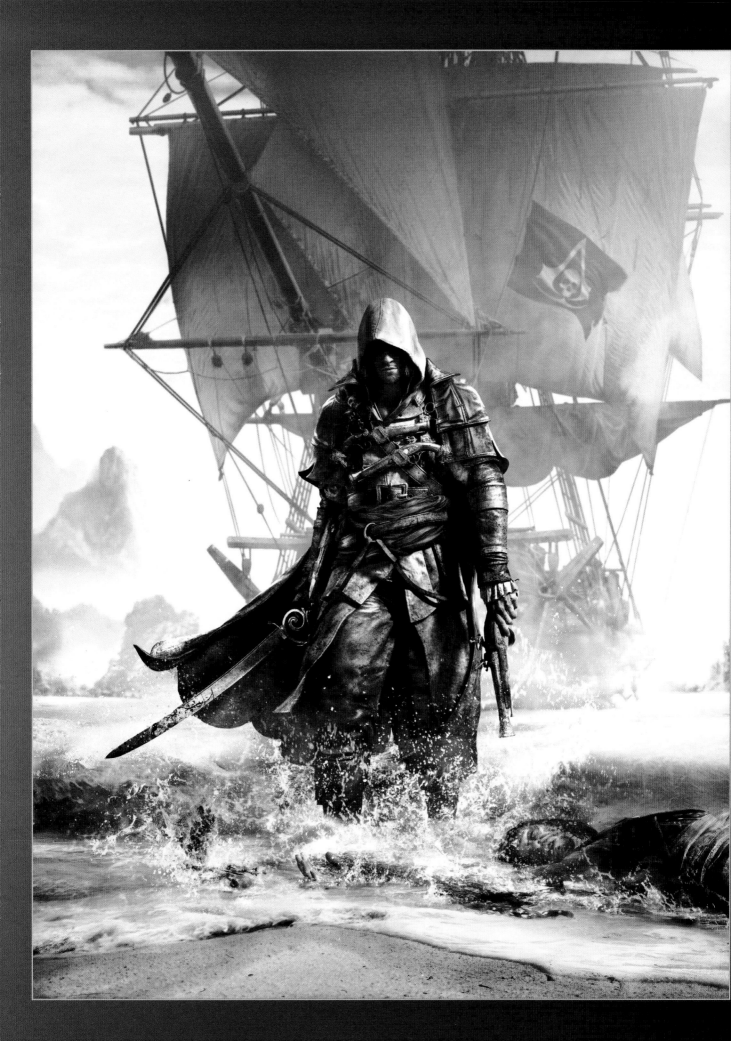

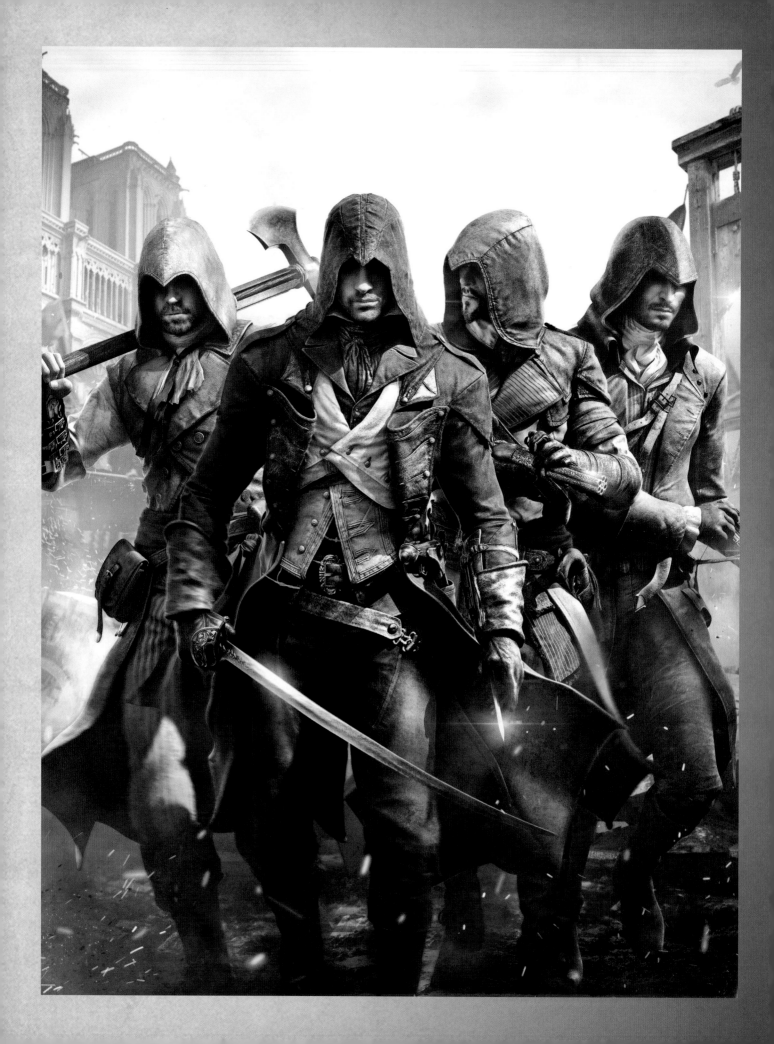

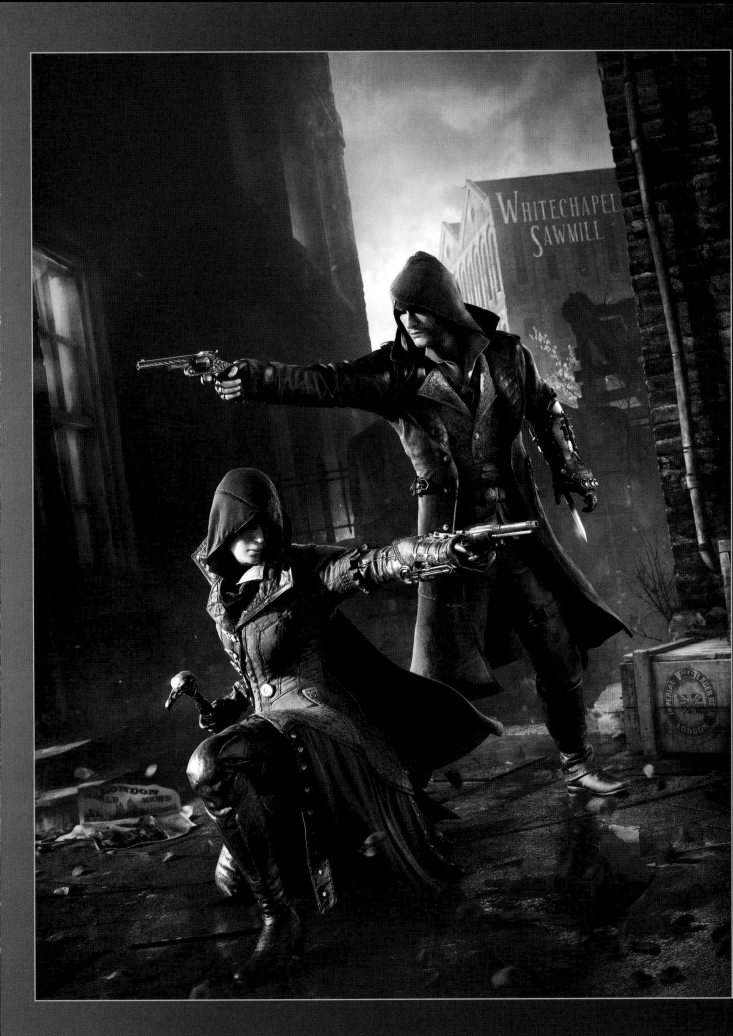

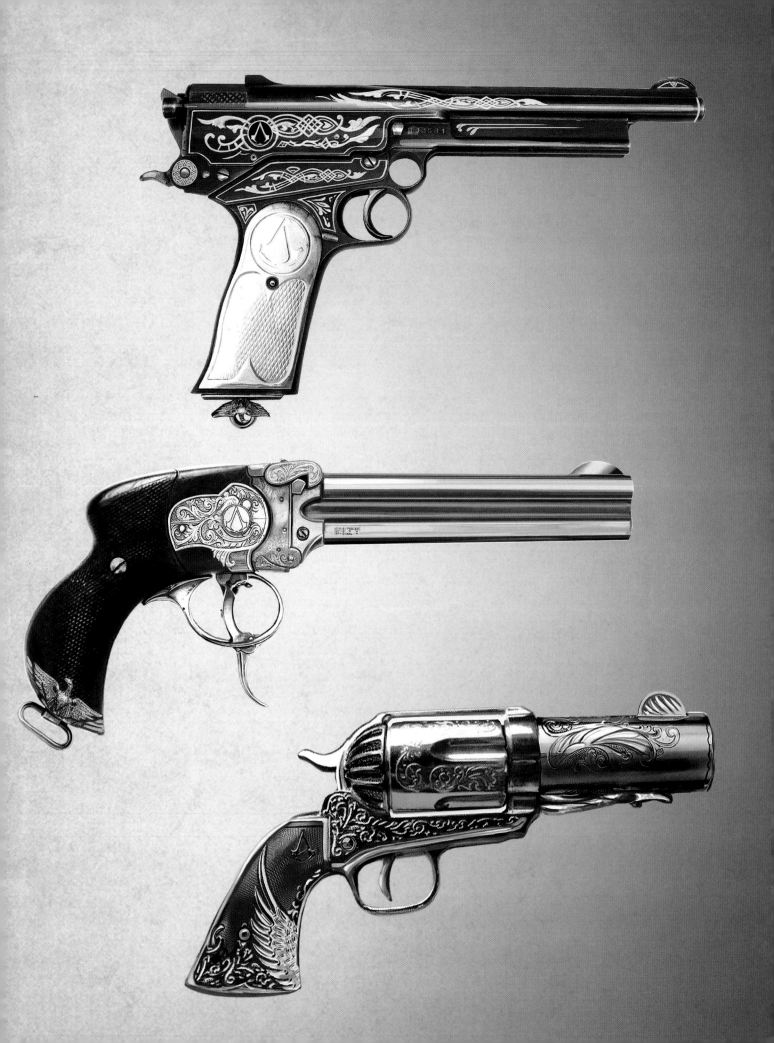

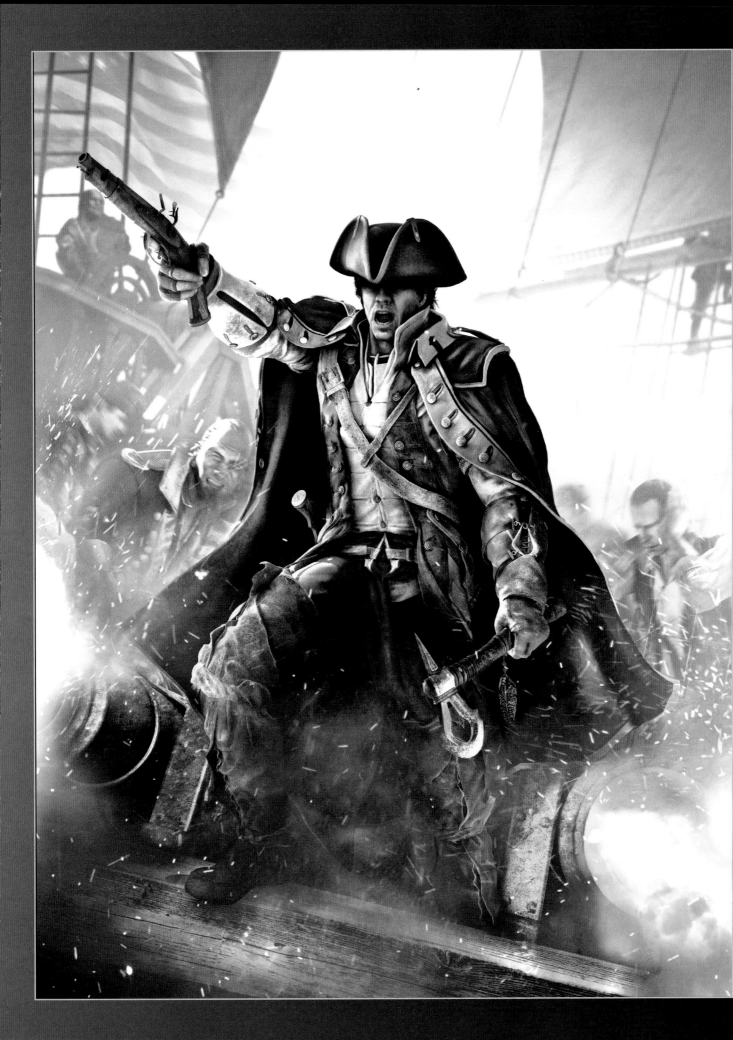

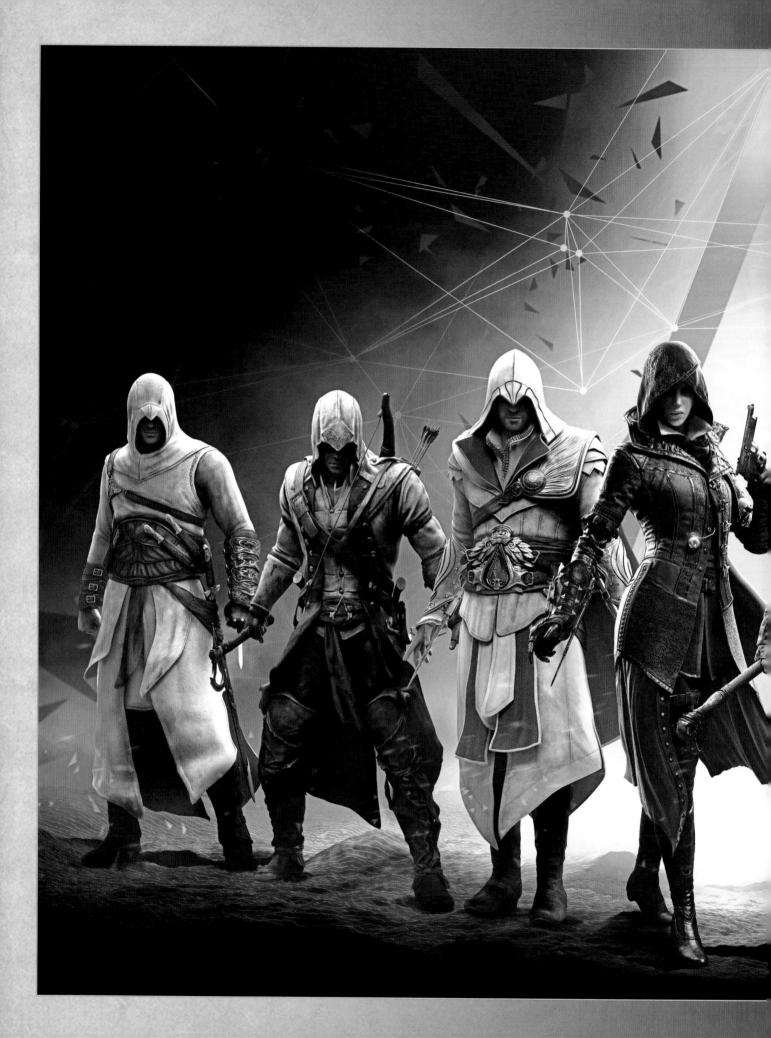

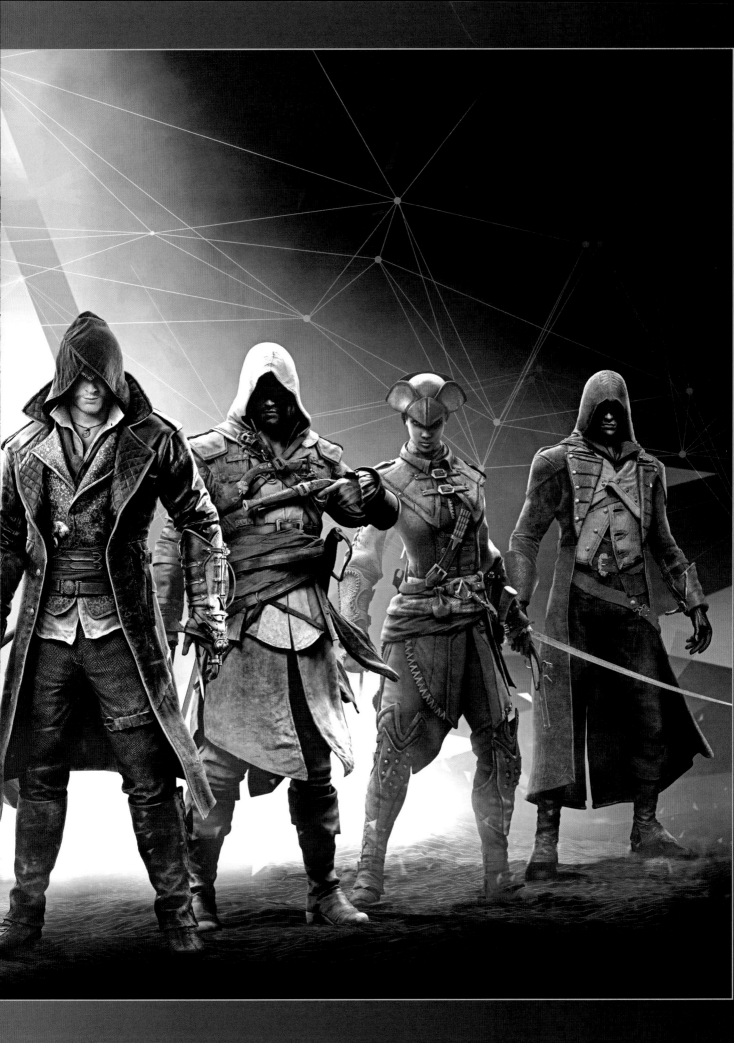

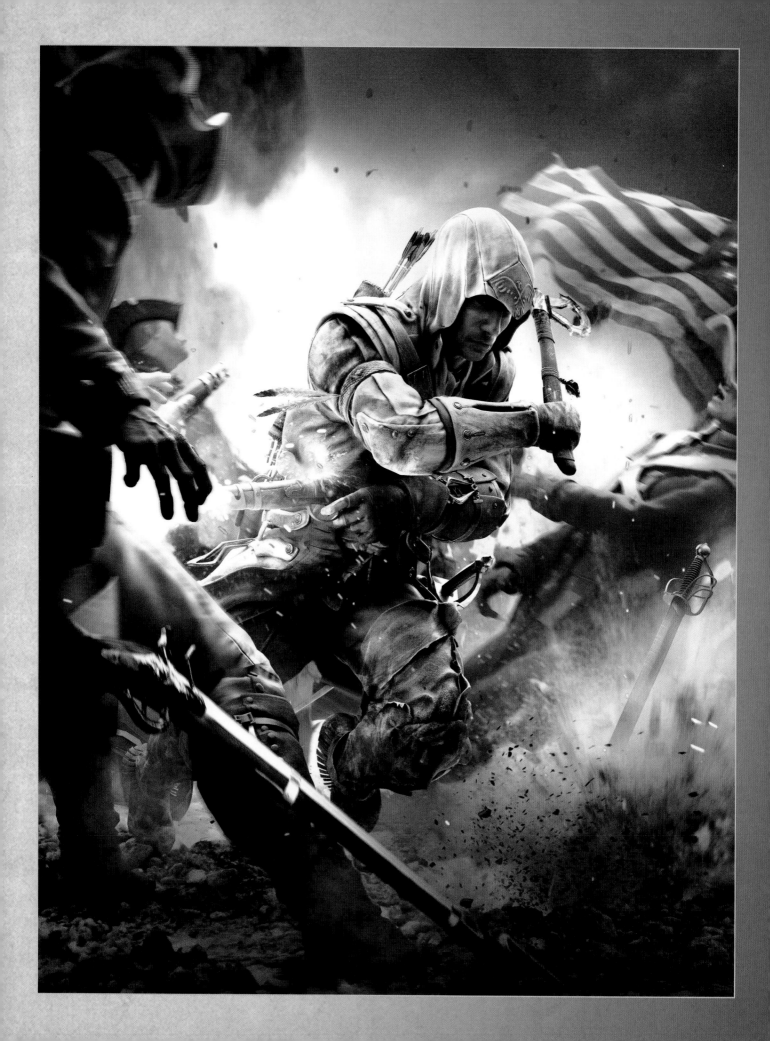

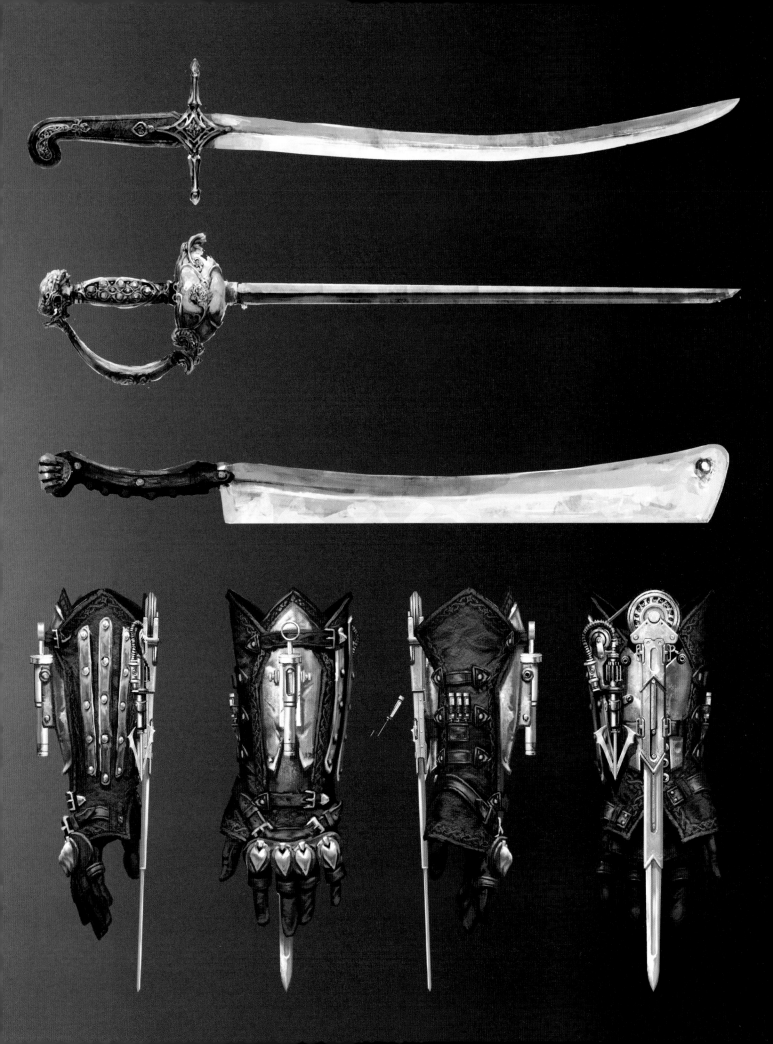

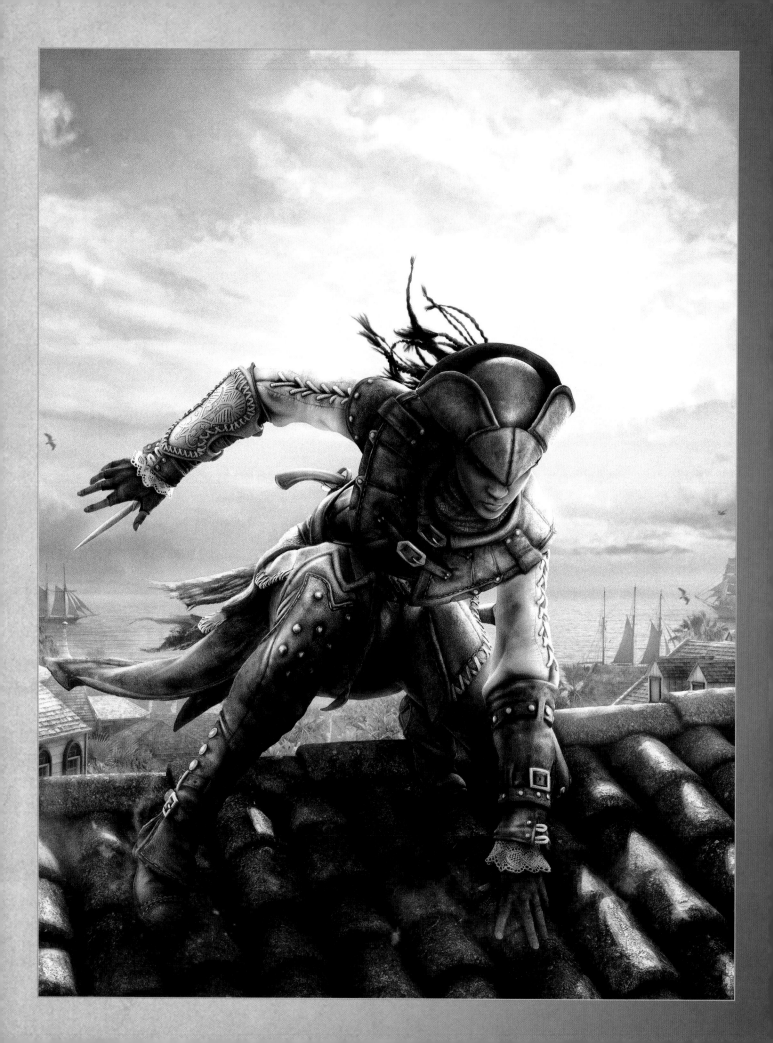

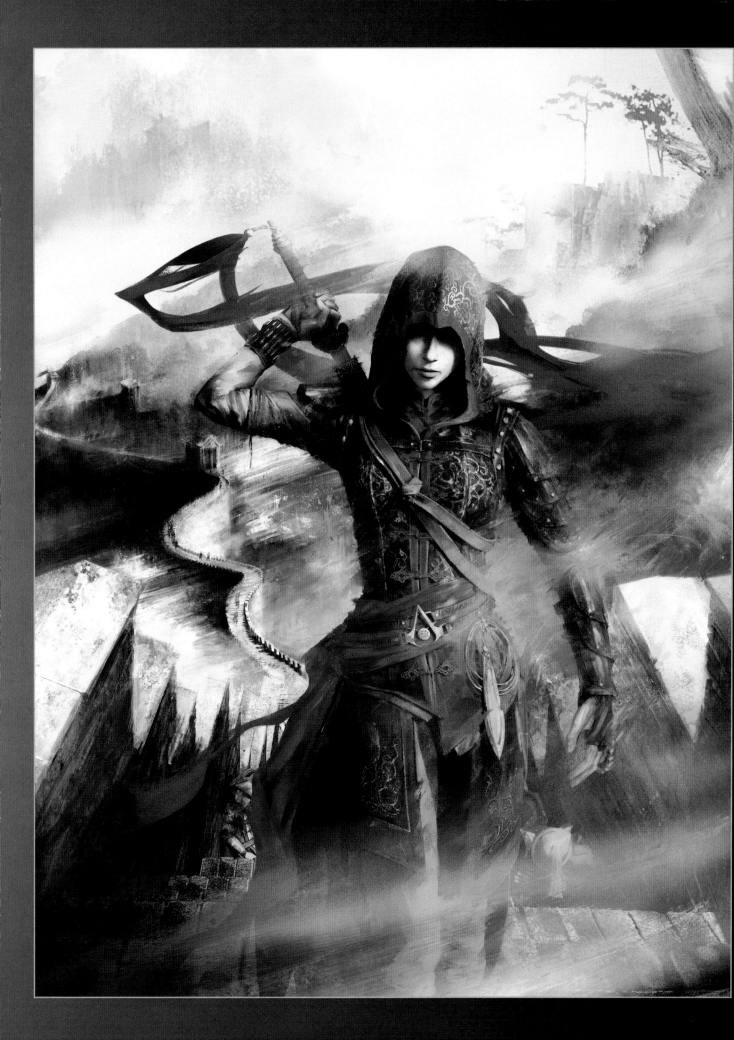

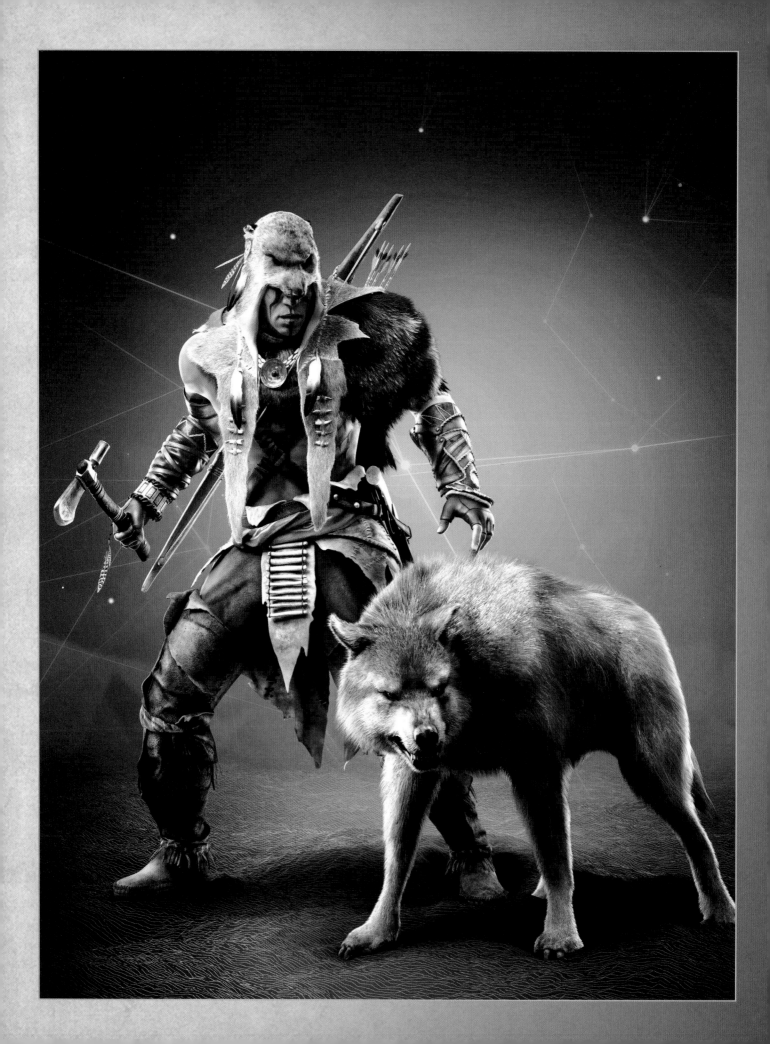

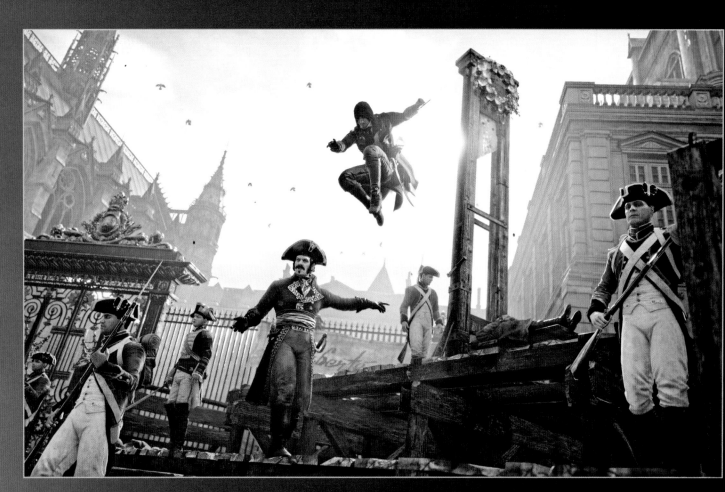

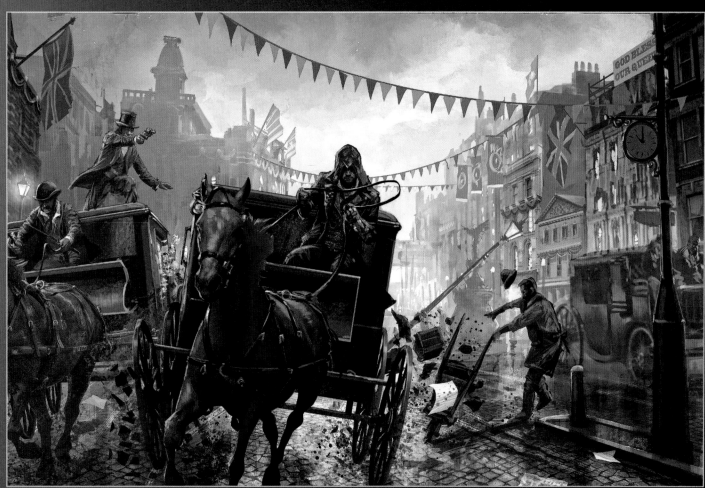

# INSIGHT EDITIONS

PO Box 3088
San Rafael, CA 94912
www.insighteditions.com

Find us on Facebook: www.facebook.com/InsightEditions
Follow us on Twitter: @insighteditions

Library of Congress Cataloging-in-Publication Data available.

ISBN: 978-1-60887-863-5

PUBLISHER: Raoul Goff
ACQUISITIONS MANAGER: Robbie Schmidt
ART DIRECTOR: Chrissy Kwasnik
BOOK LAYOUT: Leah Bloise
COVER DESIGNER: Ashley Quackenbush
EXECUTIVE EDITOR: Vanessa Lopez
ASSOCIATE EDITOR: Katie DeSandro
PRODUCTION EDITOR: Rachel Anderson
PRODUCTION MANAGER: Carol Rough
PRODUCTION ASSISTANT: Sam Taylor

—

ILLUSTRATIONS BY ADAM RAITI, ROBERT STEIMLE, AND ROBIN F. WILLIAMS.

ROOTS of PEACE     REPLANTED PAPER

Insight Editions, in association with Roots of Peace, will plant two trees for each tree used in the manufacturing of this book. Roots of Peace is an internationally renowned humanitarian organization dedicated to eradicating land mines worldwide and converting war-torn lands into productive farms and wildlife habitats. Roots of Peace will plant two million fruit and nut trees in Afghanistan and provide farmers there with the skills and support necessary for sustainable land use.

Manufactured in the United States by Insight Editions